GREEN
Neighborhood

グリーンネイバーフッド
増補改訂版

ポートランドに見る
アルチザンエコノミーという
新しい資本主義のかたち

―――――

吹田良平
Ryohei Suita

本書は、2010年に繊研新聞社より刊行された『グリーンネイバー
フッド―米国ポートランドにみる環境先進都市のつくりかたと
つかいかた』を加筆修正した増補改訂版です。
『MEZZANINE VOL.2』(トゥーヴァージンズ刊) から一部内容を、
さらに各章頭に書き下ろしページ、巻末に山崎満広氏との対談
ページを新たに収録しています。
『グリーンネイバーフッド』の原稿は2010年時点、『MEZZANINE
VOL.2』の原稿は2018年時点の内容となっています。

増補改訂版のはじめに

2010年に『グリーンネイバーフッド』（繊研新聞社）を出版して以降、この10年余り、日本ではライフスタイル、都市再生の理想像として、ポートランドブームなるものが起こった。「全米で一番住みやすい街」「官民連携まちづくりの成功例」云々だ。

でも、時代は変わる、都市は変容する。スローなライフスタイルはラピッドな経済成長に、ネイバーフッドはブームタウンに、金はなくてもなんとかなった生活は路上生活に。あの街に漂っていたファンキーなバイブスは、マネーウォッシュされてしまった。

都市政策として市が推進してきた才能ある人材の誘致戦略と活発な都市再生の結果、今やポートランドは急速な人口増とそれに追いつかない雇用市場や住宅供給、持つ者と持たざる者の経済的分断といった社会問題に直面している。都市再生と経済開発を担ってきたPDC（市開発公社）は解体され、代替する新組織はマイノリティ支援に重きを置く方針転換を果たした。

アメリカのグランジでリベラルでイケてた地方都市が、アメリカのただの大都市の仲間入りを果たしたのか。それがポートランドの目指すアーバンチェンジだったのか。ポートランドはもう終わったのか。

10年後の取材（2018年実施。初代『グリーンネイバーフッド』執筆時の取材は2008年実施。リーマンショックの影響で仕事が無くなり已むを得ず海外視察を敢行）の際、現地のあるデベロッパーはこう

話してくれた。「目標は事業利益の最大化ではない。儲けは投資採算計画に沿ったそれなりのキャッシュフローでいい。それよりは、いかに自分が夢中になれる場所を開発するかだ。俺のビルに見惚れて、車のドライバーが事故るくらいが丁度いい」。そうした考えを持つ企業はポートランドには多いから、競合に勝るよう差別化策が必要ではないか、との筆者の問いに、「最低の質問だ。自分がインスピレーションを感じるかどうかだ。人はどうでもいいし、多くの人に好かれるものを作る必要はない」。

マーケティングの地平に軸足を置かないクリエイティブなポートランダーの典型だ。大丈夫、まだちゃんと居たのだ。クリエイティビティとは、かくもタフで無垢なものと再認識できた。その時筆者の頭に浮かんだのは、ウィリアム・モリスの「労働の芸術化」である。「労働とは人間の主体的な創造行為。つまり喜びであり楽しみであるべき」の物言いだ。そういうマインドセットの人の割合が他の都市よりも少しだけ多い寛容なる実験都市ポートランドだから、AIの時代になっても、機能剥き出しの粗野な「サイエンス&テクノロジー」生活ではなく、情緒的（牧歌的？）に過ぎる「アート&クラフト」生活でもなく、絶妙のバランス感覚を発揮して「テクノロジー&クラフト」というオルタナティブを見出してくれるはず、の期待がある。

さらに、2019年に発生したCOVID-19のパンデミック以降、世界の各都市で「15／20分圏ネイバーフッド」論が喧しい。30年ほど前から採用しているポートランドでは、伝染病や

環境対策とは異なる見地での都市の近接性や高密性重視の姿勢が見えてくる。サステイナブル重視で経済成長を敵視するのではなく、サステイナブルを重視しながら経済を成長させる方法論としてのクロノアーバニズムである。

さて、この本は、2010年に刊行した『グリーンネイバーフッド』を12年振りに加筆の上、増補改訂版として再出版したものである。テーマは、創造性含有量の多い生活の質、それを形成する関係の質、その舞台となる場の質の定性的解明、つまり都市論に他ならない。決して街づくり論でも、コミュニティ論でもない点は、オリジナル版に則っている。また、改めてポートランド礼賛をするつもりも、必要以上に批判的に書くつもりもない。今でも、彼の地は良い面悪い面を含め、筆者に刺激と知恵を授けてくれることに変わりはない。ビールだって相変わらず美味しい。

日本のCBD（中央業務地区）がロジカルシンキングや企業同士の厚い壁に守られたサイロ的な拡大再生産的業務の作業場に止まっていたのでは、創造や発明の震源地になるには程遠い。OECD加盟38か国中20番台でふらつく日本の労働生産性はいつまでも浮上せずだ。業務であれ、文化であれ、娯楽であれ、共創資本が効いてハプンしている街こそが、都市の本領を発揮する。彼の地から学べることはまだまだ多い。

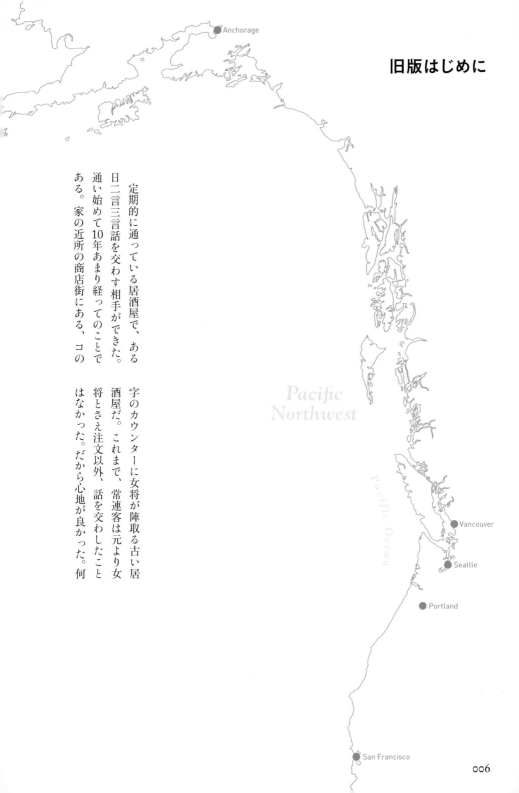

定期的に通っている居酒屋で、ある日二言三言話を交わす相手ができた。通い始めて10年あまり経ってのことである。家の近所の商店街にある、コの字のカウンターに女将が陣取る古い居酒屋だ。これまで、常連客は元より女将とさえ注文以外、話を交わしたことはなかった。だから心地が良かった。何

しろ、独りで居られたし、根っこのところでは、常連客が醸し出す店の雰囲気に親密さも感じていた。でも、話を交わす相手ができた途端、ひょっとしてその人が店に居るかもしれないと思うと、私はそれ以降なかなか店には足が向かなくなった。私は元来、「コミュニティ」という言葉に、ある種の違和感を感じてしまうほうである。

不動産開発の仕事に従事していると、しばしば「上質なライフスタイルを提案します」の表現に出くわす。商業施設、マンション、オフィスの商品企画時においてである。デベロッパーは「ライフスタイル提案」が大好きだ。でも正直言って、私のライフスタイル（そんな高尚なものがあったと仮定して）は今まで、それら提案から何らの影響を受けたことはない。友人や上司や雑誌や本からは多くの刺激を頂戴はしたけれど。だから私は、いつか「コミュニティ」と「ライフスタイル」に決着をつけたい、引導を渡したいとウズウズしていた。

2008年、私は米国オレゴン州ポートランド市にあるパールディストリクトという都市再生事例と偶然出会った。街に足を一歩踏み出した（ツアー用バスから降りた）途端、街にみなぎる雰囲気に興奮を覚えた。さらに取材を続けるうちに、あろうことか、身の丈主義ともいえる彼らの独特のライフスタイルと、自立しながら連携する風通しの良いコミュニティ感覚らしきものを実感してしまった。あるところには、あったのである。それ以降、私のポートランド通いが始まった。街を徘徊し、人と会って話を聞き、飲食店でグラスを重ねていく内にその独特のライフスタイル（というか価値観）とコミュニティ意識がおぼろげながらも見えてきたのである。それは——。

▼マーケティングの暴走があまり見受けられないこと。過度のマーケティング社会は人間を依存体質にするが、ここでは市場原理主義に染まらない、

ネイバーフッド

近隣、近所、街、区域の意。近所の人、隣人を指すneighborの派生語であることから、そこに住む人同士の関係性が強く意識されており、隣人たち、近隣のよしみ、近所づき合いの意味を含む。米国の場合、郊外一軒家の住宅街（サバーバン）が典型的なネイバーフッドのイメージ。

消費よりも創造することのほうが重視されている。

❤ 身の丈に合ったモノ、店、消費、暮らしを選択していること。つまり自分の等身大に意識的であり、加えて、その先にある自然環境に対しても意識的であるということ。

❤ 新規の開発や新製品、つまりモノ（thing）の消費・取得に対する喜びよりも、生活をいかに楽しむかというコト（event）により強い関心があるということ。イニシャル（開発）よりもランニング（運営）主体の生活観。それが成熟ということか。

❤ 良心的でバランスの取れた大衆向けの論調よりも、刺激のある革新的な姿勢を歓迎するということ。人々のハイブリットによって成立しているポートランドのユニークな都市生活像を「グリーンネイバーフッド」と名づけてみた。これらが私の稚拙な仮説創造服装から仕事に対する態度、人気の店の雰囲気などまでに、自由な気風や寛容性、自立の意識が尊重されている。

❤ さほど情報に振り回されずに自覚的な暮らしをしているせいか、物事のな暮らしをしているせいか、物事の

本質に迫る創造的思考能力が高いこと。そしてその充実のためには、アイディアが集まり柔軟にキャッチボールできる、都市という触媒が好都合だということ。

以上、私の身体的な主観を普遍化し言語知として可視化することが本書の目的である。うまく行けば経済の縮小・質の充実が求められる環境共生時代の新しい都市生活像が浮かび上がってくるかもしれないという思いがある。そこで本書では、上に羅列した各要素を次の3つの切り口に集約し、章立てることにした。第1章アーバンネイバーフッド、第2章クリエイティブシンカーの棲むところ、第3章エコエピキュリアンである（注）。そしてこれらの絶妙

街に繰り出そうではないか。である。さあ、以上を検証すべく早速

（注）本増補改訂版では、第1章アーバンネイバーフッド 新しい都市再生のかたち、第2章ハピネス・バイ・クリエイティビティ 新しいウェルビーイングのかたち、第3章アルチザンエコノミー 新しい資本主義のかたち、とした。

GREEN
Neighborhood
グリーンネイバーフッド
環境共生時代の新しい都市生活像

Urban Neighborhood
アーバンネイバーフッド

郊外ベッドタウンに替わる
都心居住者の近隣関係。
職住近接、アイディアと
ハプニングの震源地

Creative Thinkers
クリエイティブシンカー

常識や慣習を疑う度量と、
領域を越えて
アイディアをつなぐ技能を
併せもつ者たち

Eco Epicurian
エコエピキュリアン

都市同様に自然を好み、
都市をベースに全体性
（グローバル）を想像できる、
舌の肥えた悦楽者たち

Contents

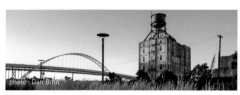

photo : Dan Bihn

photo : Daniel Paisley

序章
Prologue_Portlandia

ポートランディア
懐かしい未来のかたち

ポートランド イズ……

クールシティ、ウォームネイバーフッド
Portland Is…… Cool City, Warm Neighborhood

全米で最も環境に優しい都市 Popular Science Magazine 2008
全米で最も自転車通勤に適した都市 U.S.Census Bureau 2007
全米で最も外食目的で出かける価値のある都市 The Food Network 2007
世界一のスケートボード都市 The Wall Street Journal 2009
全米で最も出産に適した街 Fit Pregnancy Magazine 2008
独立系映画製作に適した全米10都市の一つ Movie Maker Magazine 2008
ベストデザイン都市全米第5位 Business Week 2008
ニューアーバニズムの先進10都市の一つ Business Week 2008

パシフィック・
ノースウエスト的態度

北アメリカ大陸のアラスカ南部から北カリフォルニアに至る太平洋沿岸地域をパシフィック・ノースウエストと呼ぶ。カナダ・バンクーバー、ワシントン州・シアトル、オレゴン州・ポートランドなどの都市が含まれる一帯だ。これらの都市は、太平洋沿岸部を南北に貫く2本の山脈に挟まれた盆地に位置し、豊富な雨量とそれがもたらす豊かな自然とに恵まれるという共通点をもつ。また太平洋の潤沢な水産資源を

1年を通して実り多い農作物と、険しい山々でアメリカ中東部から隔絶されていた地理的要因から、この地域には古くはアメリカ先住民族が暮らし、1960年代以降になると今度はヒッピーたちが集まり、いくつものコミューンを形成した歴史をもつ。人々の気質は総じて自立性に富み、その上寛容で自然との共生がもたらす生活の豊かさを尊重している。

享受し、取り分け深い原野を流れる河川を遡上するサーモンの聖地でもある（現在のサーモン漁獲量は50年前と比べ半分以下の水準）。

▼1 コミューン
ヒッピーたちの共同体。共同生活地。フランス語で地方行政上の最小単位を指すコミューンから派生した言葉。

▼2 コンパクトシティ
郊外へ拡大していく開発を抑制し、生活関連施設や開発行為を都心部に集中させることで実現する縮小高密化都市。

CANADA

Vancouver
Seattle

Portland ▶

USA

San Francisco
Los Angeles

Pacific Ocean

今回、私が降り立ったポートランド
は、パシフィック・ノースウエストの
シアトルとカリフォルニアの間に位置
し、市の人口約56万人、周辺都市を含
めた都市圏人口約214万人を有す
るオレゴン州最大の都市である。近年
ポートランドからシアトルに至る一体
は「シリコンフォレスト」と呼ばれ、カ
リフォルニアのシリコンバレーに次ぐ
ハイテク産業の聖地として発展してき
た。その大いなる一地方都市のポート
ランドが今、「全米で最も環境に優しい
都市」「全米で最も美味しいレストラン
が集まる都市」「ベストデザイン都市全
米第5位」などに次々と選ばれ、全米
中から注目を集めているのである。

▼2 コンパクトシティという スマート開発

その要因の一つに、オレゴン州の土
地利用制度「都市成長境界線」が挙げら
れる。これは、「オレゴンの利益は、土
地の貪欲な浪費家たちから守られなけ

ればならない」とする、かつてのトム・
マッコール州知事の演説（1973年）
に端を発して定められた制度。ポート
ランドの自然環境保存と経済発展の双
方のバランスを保つことを目的とし、都
市化が可能な土地とそれ以外とを明確
に区別した都市政策である。このおか
げで市の郊外には、新たな開発行為が
許されない広大なグリーンフィールド
が広がる。ポートランド市民は都市部
から容易なアクセスで、豊かな農作物
やハイキングトレイルをはじめとする
様々なアウトドア体験を満喫すること
が可能となっている。ここがスポーツ
＆アウトドアブランドの「ナイキ」や
「コロンビア」などの発祥の地というの
もうなずける。

一方で経済成長を促進する目的で、
開発が可能な都市部では市と民間デベ
ロッパーとの両者協調による都市再開
発が積極的に行われている。老朽化し
た建物を取り壊したり、或いはコンバー
ト（用途転換）によって、1階は店舗、2

▼3 都市成長境界線
Urban Growth Bound-
ary。略してUGB。コ
ンパクトシティを実現
するための手法の一つ
で、郊外へ拡大していく開
発を制限するための境
界線を指す。

▼4 グリーンフィールド
都市開発が行われてい
ない自然環境が保たれ
た緑地領域。ブラウン
フィールド（既に開発され
た宅地、工場跡地などの産
用地、不良債権化した遊休地
など）の対義語。

階以上にはオフィスや住居を複合させたミクストユーズ開発が盛んに行われ、高密な市街地が次々と形成されている。また都心での生活を支える手段として、ストリートカー（路面電車）、バスなどの公共交通機関が街中をくまなく網羅し（市中心部はなんと無料）、車を所有しなくても生活可能な職住近接のコンパクトシティが実現している。ここはまた全米一自転車通勤者が多い都市でもあるのだ。

都市と自然の アンフェビアン（両棲人類）

ポートランドの中心市街地は、南北に約3km、東西に約2kmと歩いても廻れるサイズで、北のアムトラック・ユニオン駅、南のポートランド州立大学（学生数約2万人）が各々ランドマークとなっている。このコンパクトな街の中で、毎月第1木曜日にはアートをテーマにしたブロックパーティ「ファーストサーズデイ」が開催され、グローバルに活躍しながらインディペンデントの姿勢を崩さない広告会社、ワイデン＋ケネディ（88頁参照）が街に創造的なオーラを放つ。また毎年3月から12月にかけては、市内至る所でファーマーズマーケットが開催されている。一方市内から車で45分程南下した所にあるウィラメットバレーには、200カ所以上のワイナリーが点在する。フランスのグランクリュ・クラスに匹敵するピノノワールは今や実力が認められた世界的にも有名だ。

このように、日常的に地元の新鮮な食材を口にしている市民は自ずと味覚レベルが高く、成長ホルモン注入などの工業製品化した食材に対する嫌悪感が強い。一方レストラン側も、質の高い食材やワインがふんだんに手に入る。そしてもちろんお客は押し並べて味が分かる。街はリベラルな気風と寛容的なムードが漂い、おまけにタックスフリー（消費税がない）。更に生活環境としても風通しの良い都市とワイル

▼5 ミクストユーズ開発
開発計画において、複数の異なる用途をあらかじめ計画的に導入・配置し、相互の関連性や共用性により発生する相乗効果を意図した開発形態。

▼6 ストリートカー
ポートランド中心部と隣接エリアを結ぶ路面電車。2～3ブロックごとに停留所がありダウンタウン内の移動はこれで十分。フリーウェイの開発中止、都市成長境界線制度と三位一体で都心部再生を実現したポートランド都市計画のキーファクターの一つ。

▼7 ブロックパーティ
住民たちが自らのブロックを舞台に執行するお祭り、イベント。

▼8 バーンズ＆ノーブル
ニューヨークに本社を置く米国最大の書店チェーン。2009

ドな自然の双方を容易に享受できるこ
とから、「独立してレストランを開業す
るならポートランド」という風潮が広
まっていった。

ここで気づくのは、従来からのポー
トランド市民にも、また新たにポート
ランドに移り住んだ新住民の間にも見
受けられる、「ローカル志向、地元優先
の精神」だ。ちなみにバーンズ＆ノー
ブルのような大企業ではない独立系書

店パウエルズブックス（192頁参照）が
カテゴリーキリングされずに存在し続
けているのもここポートランドである。

このように、地元の製品、地元の企業
を優先し、我が街を積極的に評価し、誇
りをもちながら棲むポートランド市民
のライフスタイルに、コンパクトで自
立した等身大的な都市生活姿勢という
低炭素社会を生き抜くヒントを見つけ
ることができる。

年現在、全米50州で
775店舗を展開。
2300㎡の店内に
20万タイトルの書籍、
雑誌、CD、DVDの
品揃えが平均的店舗。
米国内で販売される本
の8冊に1冊は同店で
売られたものとか。同
社の出現により数多く
の中小零細書店が姿を
消した。

コンパクトシティ
Compact City

　従来の無秩序な住宅地開発の郊外化（スプロール化）を止め、都市部に開発と人口を集中させることによって、都市部の荒廃や郊外緑地を乱開発から防ぎ持続可能な社会を達成しようという都市政策上の概念。これにより公共事業・支出の選択と集中が図られ、また自動車中心社会に代わって公共交通機関や自転車、徒歩などの活用が増加することで、高齢者にも優しいヒューマンフレンドリーな社会が実現するとの期待がある。当然のことながら、既にある郊外施設やコミュニティをどう捉えるか、都心居住を好まない層への対応はどうするかなど、影の部分も少なくない。

都市成長境界線（UGB）
Urban Growth Boundary

　オレゴン州法により1973年に制定された土地利用計画法で、開発行為が認められる都市部と認められない郊外とを区別する境界線制度を指す。　これにより、都市部では高密で効率の良い都市生活が営まれ、一方郊外では森林や農地の保全が実現している。　計画範囲（境界線）は5年ごとに見直される決まり。ポートランドでは「徒歩20分圏内の街」を目標にコンパクトシティを実現したことにより、市の人口は29％増、公共交通機関の利用は80％増、自動車利用時間は33％減（いずれも2005年：1990年比）を達成したとの報告がある。

参考文献：財団法人東京市政調査会「スマート・グロース政策に関する研究」
（東京市政調査会 2005）

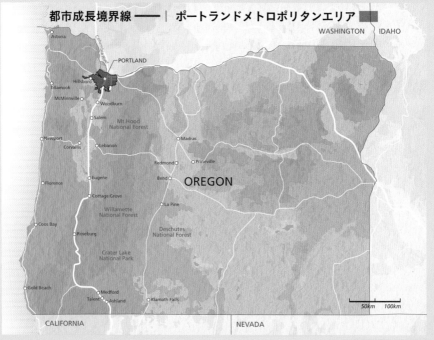

都市成長境界線 ── ｜ ポートランドメトロポリタンエリア

出所：「Map of the UGB as of May 2006」メトロデータリソースセンター

「オレゴンの利益は、土地の貪欲
な浪費家たちから守られなければ
ならない」(オレゴン州知事 1973年)。
こうして同年、UGB制度がオレゴ
ン州法として制定された

photo: Zack Benham

パールディストリクト

クールの誕生

Pearl District　BIRTH OF THE COOL

リベラルな酸素濃度の高いポートランドにおいて、その特徴が特に色濃く反映されているエリアがある。パールディストリクトだ。権威ある旅行雑誌（のはず）『Travel+Leisure Magazine』はここを「ニュー・レベル・オブ・クール」と呼び、さらに世界の公共空間の豊かさ評価を行う非営利組織PPS（Project for Public Space）は「ヒップ・ロフト・エリア」と形容する。一方、日本を代表するガイドブック『地球の歩き方』は「ダウンタウンポートランドで現在一番ホットなエリア」（ホット）が泣かせる）。

ニュー・レベル・オブ・クール!?
次世代型の格好の良い街とは

ポートランド・ダウンタウンの北西部に位置するパールディストリクトは、市の中心であるパイオニア・コートハウス・スクエアから徒歩10分程でアクセス可能な都心の再開発エリアである。一言でいうなら、かつてのニューヨークSOHOにも似たアートコンシャスでエッジの利いた雰囲気が漂う旧倉庫街だ。エリアの概要は次の通り。

敷地は南北に1km、東西に750m、面積にして東京ドーム16個分程の規模で、その中は約100のブロック（街区）で区切られている。街には約25軒の

アートギャラリー、60軒のホームファニシングストア、50軒のカフェ・バー＆レストラン、60軒のブティックが建物の1階に店を構え、ストリートスケープ（街並み風景）を形成。このほかにも3校のアートスクール、オフィスと1900戸の住居が混在し、加えて夏の間にはファーマーズマーケットや幾多のブロック・パーティ、ストリートフェアが開催され、街はまるで一つの施設のように連携し合いながら息づいている。そのパールディストリクトをアメリカのメディアは次のように紹介している。

「ワールドクラス・ミクストユーズ・コミュニティ」「モダーン・アップス

の間にはファーマーズマーケットや幾多のブロック・パーティ、ストリートフェアが...

▼1 パイオニア・コート
ハウス・スクエア
ポートランドの居間（ポートランドリビングルーム）とも形容される、市中心部にある公共広場。床に敷かれている煉瓦は建設資金を集めるために広く市民に売られたもので、寄贈者の名前が刻まれている。屋外映画上映会場から、時には枕投げ大会の戦場ともなる、まさにポートランド市民のリビングルーム。いやベッドルーム!?

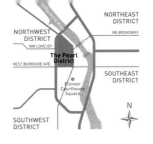

NORTHEAST
DISTRICT
NE BROADWAY
NORTHWEST
DISTRICT
NW LOVEJOY
The Pearl
District
WEST BURNSIDE AVE.
SOUTHEAST
DISTRICT
Pioneer
Courthouse
Square
SOUTHWEST
DISTRICT
N

ケール・ネイバーフッド」「グレートダイバーシティ」「ニュー・アーバン・コミュニティ」「アーバン・リビング・エクスペリエンス」といった具合だ。

日本で行われているミクストユーズ開発の多くは、一つのまとまった敷地で開発主体一社（一組織体）による自己完結型複合開発であるのに対し、パールディストリクトの場合は100からなるブロックを舞台に、個々の建物ごとに開発会社が異なる、文字通りの街の創出である。したがって開発の完成以降、ビル名やプロジェクト名（例えば六本木ヒルズや東京ミッドタウン）で呼ばれることが多い日本のケースとは異なり、コミュニティやネイバーフッドが正しい表し方となる。もう少しだけ、都市開発的な話を続けさせてもらう。

やがて曇った「輝ける都市」
ル・コルビジェ

かつての日本の高度成長の時代には欠乏充足型の経済、つまり第2次産業を基幹とした規格標準品の大量生産が優先されていた。そのため都市計画においても、それを効率良く機能させるのに適したゾーニング法（土地の用途を制限する都市計画法）が採られていた。工場・職場・住居の各エリアを法律によって明確に区分するやり方だ。この機能優先の合理主義で都市を構成した場合、極まるところは「道は直線で格子状であるべき」「区域はオフィス地帯、工業地帯、商業地帯、住宅地帯のように機能別であるべき」の考え方である。「都市とは純粋な幾何学である」で有名なル・コルビジェの▼3「輝ける都市」論だ。しかし、この思想が実践されたチャンディーガル（インド）やブラジル人建築家ルシオ・コスタの手によるブラジリア（ブラジル）は市民生活を送るには極めて不便の烙印が捺されている

一方、早い時期から土地ゾーニング法の弊害について警鐘を鳴らしていた見識者もいた。米国評論家・ジャーナリストのジェイン・ジェイコブス▼4であ

▼2 ストリートフェア
生活道路や大通りを一区間すべて封鎖し歩行者天国とした上で、行われるイベント。

▼3 ル・コルビジェ
1887〜1965年。スイス生まれで主にフランスで活躍した建築家。モダニズム建築の提唱者。「住宅は住むための機械である」「低層過密な都市よりも超高層ビルを建て、周囲は緑地にすべき」など、建築・都市計画分野における機能性・合理性を提唱した。

る。彼女は著書『アメリカ大都市の死と生』[黒川紀章訳・鹿島出版会・1977年]の中で、都市が都市自体の文明を維持していくには、多様性こそが最も重要な要素であるとし、具体的に次の4つの条件が不可欠だと述べている。

① 「1つの基本的な機能だけではなく、2つ以上の機能を果たすこと」。それによって都市は、多様な目的と様々に異なる時間帯に訪れる人々で活気づく。

② 「各ブロックは短くなければならない。街角を曲がる機会は頻繁でなければならない」。それによって都市は、専門家以外の市井の人々に対しても可能性と触媒作用を及ぼす。

③ 「建てられた年代と状態の異なる様々なタイプの建物が混在していなければならない」。大企業のみならず、色々なステージの事業者に機会は与えられるべきである。

④ 「どんな目的であろうと、地域には人口が充分密に集中されなければならない」。多くの豊かな相違や可能性の集中、つまりバラエティさが都市にバイタリティをもたらす。

一方、そもそもスプロール化による弊害を考慮に入れなくても(第一私はそんなにエシカルな人間ではない。長くベッドの中に留まり、夜30分でも長くカウンターに座っていたいだけだ)、アイディアの生産を生業としている人間にとって、仕事のオンとオフは分かち難く地続きであり、住む場所、考える場所、遊ぶ場所など、各機能の重層・融合によるアイディアの熟成作業(知人からの批評と修正)は日常的必然だ。つまりアイディアを扱う人種にとって、人と情報と飲食店の集まる都心以外は植生的限界なのである。既に70年代にそれを見通した浜野安宏氏は、青山のFROM-1stビル開発にあたり、当時次のように述べている。

「とりわけ我々のようなソフトな仕事をする集団にとって、仕事場と遊び場は分離して考えることはできない。仕事場をトータルなライフスタイルの場

▼4 ジェイン・ジェイコブス
1916〜2006年。アメリカ生まれ。業界紙記者、フリーランス寄稿家として活躍。都市論をはじめ、経済論、倫理・哲学などの分野で文筆活動を続けるとともに建築フォーラムにスタッフとして参加。アカデミズムや組織に属さない独立不羈の思想家として世界的に知られる。

▼5 浜野安宏
1941年京都府生まれ。ライフスタイルプロデューサー。株式会社浜野総合研究所代表取締役社長。FROM-1st、東急ハンズ、AXIS、渋谷QFRONTなどの商業施設を中心に数多くの総合プロデュース、コンサルティングなどを手がける。

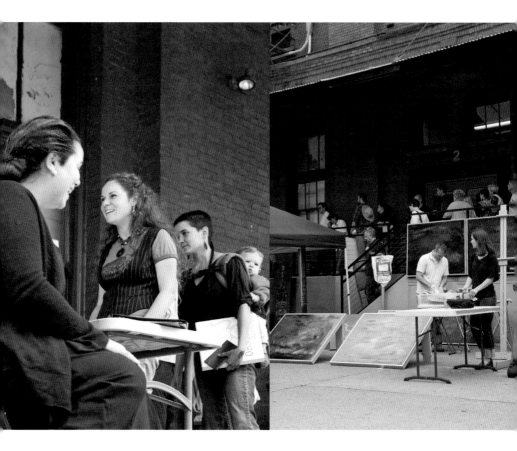

「ミュージアムを誘致することが都市をクリ
エイティブにする要因とはならない。大切な
のはストリートに芽生えるユーススピリット
のほうである」
ジョン・ジェイ（ワイデン＋ケネディ／グローバル・
エグゼクティブ・クリエイティブ・ディレクター）

と考えねばならない。〈中略〉はたらく、生きる、楽しむ、それらは一つのことである。切り離して別々のところに置くのではない。〈中略〉私は都市の変化を、人間が最後には全体性の回復を目指して行動するようになることを実証してみせたかった」(『浜野商品研究所コンセプト&ワーク』商店建築社・1981年)

Work, Live & Play
グレートダイバーシティ

そこで、パールディストリクトである。ここでは職住遊の各機能の融合(ミクストユーズ)を前提としたグレート・ダイバース・コミュニティ[6]が具体的な形となって実現している。その多様性とは、

- ▼住機能はタウンハウス[7]からロフト、コンドミニアム[8]、アパートメントまで
- ▼グレードは中所得者用から富裕層向けまで
- ▼機能は商業施設、ガレージからオフィスまで
- ▼コミュニティの成員はヤッピー[9]からアーティストまで、また世代は子育て世代からエンプティネスター(子どもが巣立った世代)まで
- ▼店舗はローカル・ファミリー・ビジネスからグローバルブランドまで
- ▼交通手段はシェアカー、ストリートカーから自転車、セグウェイ、スケートボードまで
- ▼建物はモダンデザインのハイテクコンドミニアムから19世紀製の倉庫まで
- ▼書店パウエルズブックスにおいては新刊書から古書までが同一の棚で

パールディストリクトでは、以上のように様々な要素が融合し多様性を発揮しながら独特の癖ある都市社会が営まれている。背景にはインテルに代表されるハイテク産業の集積があるのは確かだ。しかし注目すべきは、それらに勤務するヤッピーたちの少なからずが、従来の郊外一軒家に代わって都心居住を選んでいるという事実だ。それをポートランドダウンタウンに漂う自

▼6 ダイバースコミュニティ
ダイバースは多様性を意味する形容詞。ダイバースシティはここでは多様性に富んだ居住者による共同体の意。

▼7 タウンハウス
共用の庭をもつ、二戸建ての住宅が複数連なった低層の集合住宅。元来はイギリスの郊外住宅(カントリーハウス)に対する都市住宅を意味していたが、現在は構造のみを指して使われている。

▼8 コンドミニアム
米国における分譲マンションの意。

▼9 ヤッピー
young urban professionalsの略。米国で第2次大戦後に生まれたベビーブーム世代で、都会に好んで住む知的職業に就いているエリート。

由で寛容な空気のせいばかりにするのは少々乱暴であろう。むしろそこには行政側の明確な都市運営ビジョンとそれを実現するための柔軟な（しかもシンプルな）方法論、更に「消費や所有を越えたところの何か」を楽しむ暮らしという価値観があるような気がしてならない。それが私の感じるパールディストリクトならではの「アーバン・リビング・エクスペリエンス」であり「ダイバースブレンド」とも呼ばれる街の雰囲気である。

「都市の多様性は、それ自体さらに多様性を増すことを可能にし、それをさらに増進させる」（ジェイン・ジェイコブス）。

「情報は情報を誘導する」（松岡正剛[10]）。

「人は人のいるところにあつまってくる」（浜野安宏）。

毎月第1木曜日の夕方6時から夜10時過ぎまで、パールディストリクト内の3つのブロックを閉鎖して行われるアートをテーマとしたブロックパーティ「ファーストサーズデイ」。毎回の来街者は2万人規模。このイベントによってパールディストリクトは月に1度、アーバンハイブ（都市の聖地）と化すのである

▼10 松岡正剛
1944年生まれ。株式会社編集工学研究所所長。オブジェマガジン『遊』元編集長。

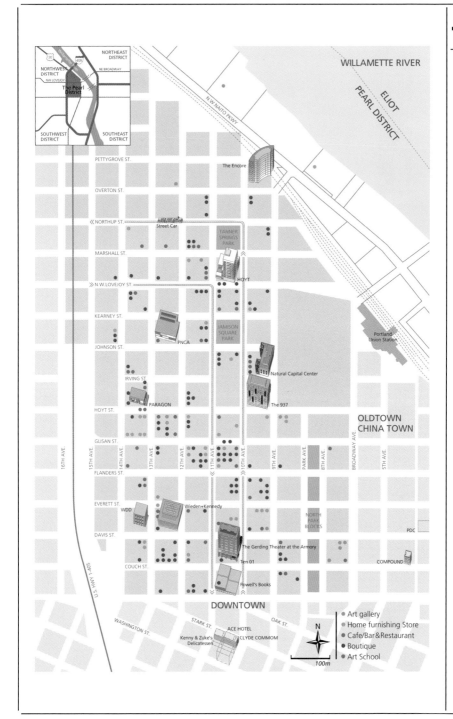

WILLAMETTE RIVER

ELIOT PEARL DISTRICT

OLDTOWN CHINA TOWN

DOWNTOWN

- Art gallery
- Home furnishing Store
- Cafe/Bar&Restaurant
- Boutique
- Art School

N
100m

パールディストリクト・マップ

The MAP of Pearl District

026

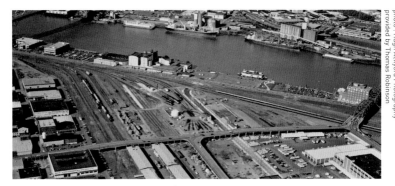

<blockquote>photo : Hugh Ackyord Photography
provided by Thomas Robinson</blockquote>

開発が始まる以前、操車場当時のパールディストリクト

パールディストリクト・ヒストリー

　パールディストリクトが今の姿をみせる前、元々ここは1900年初頭に操業を開始したバーリントン・ノーザン鉄道の操車場及び輸出用農産物などの貨物の倉庫基地であった。1950年代に入ると貨物輸送の主役は鉄道からトラックへと移行。それにともないここの事業規模も徐々に縮小していき、ついには荒れ果てたブラウンフィールド（工場跡地）として長い間放置されるままとなっていた。

　1980年、地元のデベロッパーが放りっぱなしの1棟の倉庫に目をつけ、買い取って貸倉庫業を開始。これが操車場兼倉庫街の最初の再活用事例とされている。1988年、ニューヨーク、ボストンへの出張から戻った同事業主は、既に東部で脚光を浴びていたロフトに倣って、更にいくつかの倉庫を買収しロフト物件としてビジネスを始めた。思惑通りロフト文化に憧れるアーティストたちから人気の火がつき、やがて操車場兼倉庫街はロフト・エリアとしてアーティストたちの間で一躍ホットスポットに変貌を遂げた。ここまではまだ、あくまで既存の古い倉庫を利用したニッチな土地活用に過ぎない。

　やがて1994年、地元の別のデベロッパー、ホイト・ストリート・プロパティーズ（ホイト社。38頁参照）が、バーリントン・ノーザン鉄道から34エーカー（約14万㎡）のまとまった土地を6億ドルで取得。丁度、都心に隣接したこの広大なブラウンフィールドの再生を構想していた市政府と思惑が一致した上での英断である。同社は市の描くマスタープランを念頭に、民間ビジネスレベルでメリットのある事業計画を試行錯誤した末、3年後の1997年に市との間でエリアの共同開発をうたったPPP（パブリック・プライベート・パートナーシップ）契約を締結するに至った。

　その後、両者は協調し合いながら次々と開発を進め、以降約10年間で「全米で最も成功した都市再生プロジェクトの一つ」と言われる現在の姿を実現したのである。

　ちなみにパールディストリクトの名前の由来は、ある地元のギャラリストが、このエリアに多いアーティストたちの古いロフトを真珠の殻に、彼らの作品を光り輝く真珠に見立てて名づけたという説が有力だ。真意はともかく、アートやアーティストたちの自由な創造性が、落ちぶれた操車場兼倉庫街を再生するきっかけとなったのは紛れもない事実なのである。

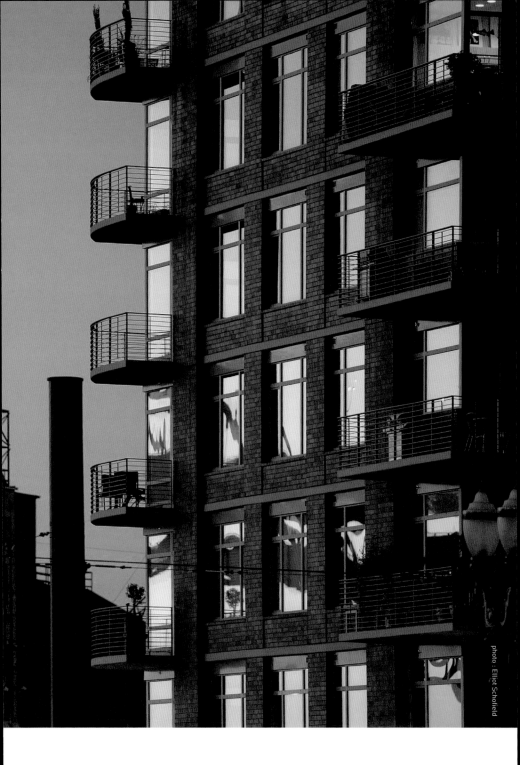

スタートアップ企業にも機会が与
えられるように、古い建物と新し
い建物が混在していること。世間
に刺激を与えるのは、大企業より
血気盛んな新興勢力であることが
多い

「都市は多様性を、都市が形づく
る様々な経済効果の蓄積によっ
て生み出す」
ジェイン・ジェイコブス

地元日刊紙『ザ・オレゴニアン』
1850年12月4日に創刊された、
米西海岸で最も歴史ある新聞の
一つ。ピュリッツァー賞の常連で
もある

I 章

Chapter I_Urban neighborhood

アーバンネイバーフッド
新しい都市再生のかたち

アーバンネイバーフッドをつくる

複合開発か融合開発か

ネイバーフッドとは近隣地区や界隈を意味する単語だ。地域そのものを指すこともあるが、隣人や近所の人を表すネイバー（neighbor）に集合体の意をもつフッド（hood）が接続した単語である。

ことから、本来は歓楽街やビジネス街とは異なり、人が住む地区を指す。今でも、郊外の住宅街を指してネイバーフッドとよく使われる。

この典型的な郊外のネイバーフッド。イメージとしては、映画「バック・トゥ・ザ・フューチャー」や「アメリカン・ビューティ」に出てくる、芝生の庭を伴った平家の一軒家の連なりが典型。平日は自転車に乗った新聞配達人が家のポーチめがけて新聞を放り投げる朝の光景、週末は庭を舞台に父親がBBQでファミリーアフェアに勤しむ光景が思い浮かぶ（ローカル紙を発行する新聞社の合従連衡とデジタルシフトにより新

開業界は青息吐息だが）。こうした、住宅という都市機能だけで構成された純粋ネイバーフッドでは、大人が仕事に出かけた後の日中、街に存在するのは子どもと老人、そして郵便配達人や宅配便に限られる。365日だ。街を構成する要員が長期で限定・固定されるため、そうしたネイバーフッドからは徐々に開放的で寛容な雰囲気は失われ、代わって同調圧力や排他意識、ひいては同質化傾向が街を覆い始める。同様のことは日本にも当てはまる。

一方、全米で最も成功した都市再生プロジェクトとも言われる、ポートランド市内のパールディストリクト。この再生エリアは、アートギャラリー、飲食店、ホームファニシング店やアパレル、アスレチック、ホテル、大学・専門学校、そして7千人程が住む住宅と2万人程が働くオフィスから成る。一辺が60ｍの正方形の街区、約100ユニットで構成された120haの都市

歩くだけで住人の気配とその日常生活を垣間見ることができるため、ここは紛れもなくネイバーフッドである。と同時に、旅行者をはじめ、店舗や学校、そしてオフィスをめがけて数多くの人間が外部からここを訪れるため、街を構成する要員は一様ではなく絶えず変化を繰り返す動的平衡状態を成している。よって、風通しがいい。まさに24時間365日、各々異なる動機で異なる時間帯に使用するミクストユーズの街である。加えて、住んでいる人の顔が見え、存在が感じられることから郊外住宅街のネイバーフッドとは区別して、都市型ネイバーフッド、アーバンネイバーフッドとでも呼びたくなる。

これは、日本に多い、オフィスタワーをメインに低層部を商業施設で固め、そこに文化施設とタワーマンションを複合させるといったミクストユーズ開発とは似て非なる。日本の場合、都市機能は確かに複合してはいるが、施設利

用者同士が相互に多角的に利用し合うことは少ない。また住んでいる人の気配を感じることも稀である。住民は「勝ち組」とも称されて、その存在は特別視、あるいは隔絶視さえされている。いわば各機能が分離独立したマルチユーズ型開発(文字通り「複合開発」)に近い。違いは、それだけではない。

エートス駆動の
ミクストユーズ・コミュニティ

都市を舞台に複数の都市機能が効率的に複合したとしても、それだけではアーバンネイバーフッドとはならない。パールディストリクトには明らかに一つの具体的なエートスが存在しているのだ。それは、郊外の静かでゆったりとした一軒家での暮らしよりも都市の喧騒を選択する暮らし。安定よりも都市の文化的刺激や機会を求める暮らし。ことさら仕事と余暇、オンとオフを分けない暮らし。人と接続したり知らない事象と出会ったりすることを厭わな

い暮らし。そこから得られる自らの向上や変化や成長を能動的に求める暮らし。アートギャラリーであり、文化テーマのタウンイベントであり、質の高いレストランであり、マーケットイベントであり、公式自転車レースであり、この街には、そうした仕掛けが具体的にセットされている。それがこの街のエートスであり、だからこそ、その価値観を一にする者が、ここにオフィスを構え、家を借り・買い、店舗やギャラリーを構えるのである。紛れもなくここにはある種の価値観の共有がある。その意味で、ここは地域共同体であり、それも居住者に限定しない、価値観を共有するゲゼルシャフトとゲマインシャフトの融合であり、だからこそアーバンネイバーフッドなのである。

生活の質（QOL）を超えて

街が具体的なエートスを掲げた場合、その行き着く先はどうなるか。街が掲

げる方向性やキャラクターといったものに賛同する者が積極的に選択してその街に集まる。それがどれ位の持続性を持つものかは計り知れない。来てみたはいいものの、イメージとは違ったとしてそこを後にする者もいるだろう。

でも、居続けた人は、しばらくすると街に対する帰属意識が芽生えてくるに違いない。知人を招いては街の自慢をひけらかすこともあるだろう。やがてそれは誇りとなるに違いない。さらに時間が経過すると、その帰属意識は街に対する自治意識へと変容するだろう。

パールディストリクトの町内会長はかつての取材でこう話してくれた。

「もちろん無関心な人はいます。特に最近新しい居住者も増え、コミュニティを一つにまとめるのが難しくなっているのは確か。でも、パールは建物も住人もミクストユーズな点ではポートランド随一。メンバーは高度な専門職に就いている人も多く、各々の知識を利用しながら、その経験を我が街に生か

そうとコミュニティ内でネットワーキングを行い、フォワードシンキングで街を良くしていきたいという思いで動いている」。

この見地にまで至ると、私益と公益の区別もミクスト（融合）してくる。筆者のような昭和無責任男は私益と公益とを明確に区別し、公益は役所の仕事とばかり、公共サービスの消費者に成り下がっている。ところが、パールディストリクトの住民は、こう言うのである。

る。「公益とは私益の総和である」。もう少し、話を飛躍させたい。生活の質に対する捉え方の違いについてだ。彼らと接して感じるのは、どうやら生活の質とは享受するものでも消費するものでもなく、勝ち取るものだという認識だ。では勝ち取るものとは何か。それこそが、彼らが強くこだわる場の質であり、関係の質なのである。そして、それらを勝ち取るための活動自体が、生活の質そのもの。そう思えてならない。

デベロッパーは
コミュニティライフの夢をみるか

ホイト
HOYT.

良いデベロッパーの条件とは、ビジョネアーであること。
自ら開発を手がける場所でどんな生活が営まれるのか、
どんな日常を営んでほしいのか。それを描くためには、
素質としての人間力が不可欠だ。都市生活者力と言い換えてもいい。
パールディストリクトの場合、鍵を握るのはホイト社だ。

公共的センスの
民間デベロッパー

「そもそもポートランドはアプロー
チャブル（取っ付き易い、気さく）な都市
だ。色々なタイプの人たちや様々なア
イディアを拒まず受け入れる土壌を
もっている。私にはまるで街全体が〝話
し掛けてきてもいいですよ〟といって
いるような気さえする」。そう話すのは、
ホイト社コンストラクション担当副社
長ドーグ・シャピロ氏だ。彼自身数年
前にニューヨークから移り住んできた
一人である。

　ホイト社は、パールディストリクト
を今の姿につくり上げたポートランド
ベースのデベロッパーだ。それまで古

くからの倉庫を利用したアーティスト
たちのロフトコミュニティはあったも
のの、あくまで寂れた倉庫街でしかな
かった。そのパールディストリクトに
逸早くビジネスチャンスを見出し、
1994年34エーカー（約14万㎡）もの
土地を取得。それが事実上のパール
ディストリクト誕生のきっかけとなっ
た。

　土地購入後、同社は早速このエリア
の都市再生マスタープランを描いてい
た市行政サイドとの間で協議を重ね、多
岐にわたる支援を取りつけていった。市
側としても、空洞化した都心エリアに
おいて都市再生プレイヤーの出現は
願ってもないチャンスであった。こう
した行政セクターと民間セクターの二

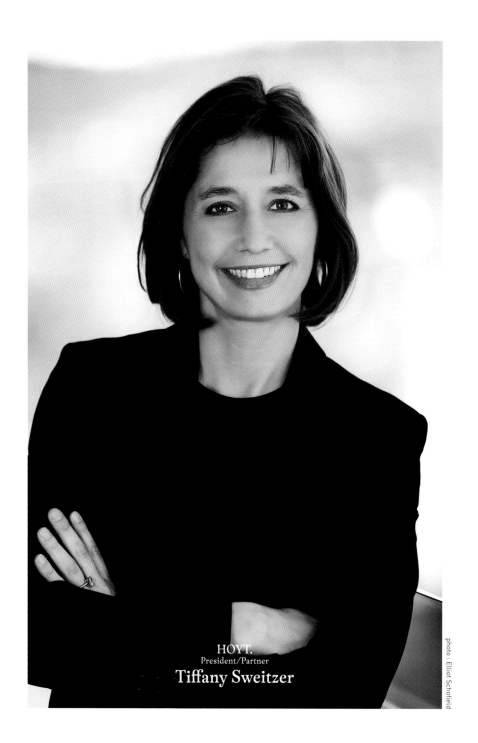

HOYT.
President/Partner
Tiffany Sweitzer

photo : Elliot Schofield

人三脚による都市再生手法はPPP（パブリック・プライベート・パートナーシップ）と呼ばれ、公共的センスをもつ民間デベロッパーと、私企業的決断力と政策執行能力に長けた行政機関が出会って始めて実現するコ・ワークである。具体的に両者の役割分担から、ここでのギブ＆テイクの一端を紹介する。

ポートランド市側の要請事項

▼ 空洞化したブラウンフィールドを民間活力を使って再生する（都心居住者／税収のアップへの期待）▼2

▼ 土壌改良（列車のディーゼルオイル等廃棄物による土壌汚染）

▼3 アフォーダブル住宅開発

▼ 公共公園の整備

民間デベロッパー側の要請事項

▼ エリア内に掛かる高架道路の撤去（ウォーカビリティの実現）▼4

▼ ストリートカー（路面電車）のダウンタウンからの延伸

▼ 建ぺい率・容積率・高度制限等建築条件の緩和

ライフスタイルのビジョネアー

両者間にて業務分担が確定した後は、今度はデベロッパーの力量が街のレベルを決定づけることとなる。都市生活者の欲望をどこまでイメージして汲み取り、そこにプラスαの魅力を付加しながら具体的都市体験として街区に落とし込んでいくことができるか。デベロッパーのビジョネアーとしての人生経験、見識、審美眼、知恵、センスの総和＝都市生活者力が試される番だ。

「私たちはアーバン・リビング・エクスペリエンスとセンス・オブ・コミュニティをここに実現しようと考えました。一般のデベロッパーであれば、個々の建物開発に注力すべきところを、私たちは〝ビルド・ザ・アーバン・ネイバーフッド（ネイバーフッドを創出する〟）をコンセプトとして掲げたのです」（ティファ

▼1 PPP（パブリック・プライベート・パートナーシップ）
官と民がパートナーを組んで行なう共同事業。事業の企画段階から民間事業者が参加するなど、より幅広い範囲で基本的な事業計画をつくり、資金やノウハウを提供する民間事業者を入札などで募るPFI（Private Finance Initiative：プライベートファイナンスイニシアチブ）との違い。

▼2 ブラウンフィールド
既に開発された宅地、工場跡地などの産業用地、不良債権化した遊休地等を指す。グリーンフィールドの対義語。

▼3 アフォーダブル住宅
元来、収入に応じた適正な家賃・価格の住宅という意味であるが、現在米国で「アフォーダブル住宅」という場

HOYT.
Vice President of Construction
Doug Shapiro, AIA

ニー・スウィッツァー・ホイト社代表）

具体的には高架道路を市側に撤去さ
せてウォーカブルな環境を整えた上で、
公園を開発して市に提供（維持は市側が
担当）、ストリートカーを街の繁華街か
ら延伸させることでダウンタウンと地
続きとし、その上で高級コンドミニア
ムを中心としたミクストユーズ開発を
次々と手掛けていった。ユニークなの
は、いずれの建物も1階は店舗やギャ
ラリー用途に制限し、竣工後も運営管
理を同社が継続して行う手法をとった
点だ。これによって将来にわたってテナ
ントを一定レベルに保つことが可能とな
る。またコンドミニアムには零細企業や
アーティスト向けの職住兼用住戸を一

定量必ず設置。さらにパールディスト
リクトの個性でもあるアートとの親和
性を街づくりに活かすべく、月に1度
の街を挙げてのアートイベント（ファー
ストサーズデイ）の支援を行っている。
その結果、パールディストリクトは
約10年でポートランドで最もウォーカ
ブルなアーバンネイバーフッドとなっ
ただけでなく、全米で最も成功した都
市再生プロジェクトとして知られるよ
うになった。現在ホイト社では、パー
ルディストリクトを「LEEDネイ
バーフッド・デベロップメント（建物単
体ではなく、街単位によるLEED／環境性
能評価制度）」に申請中である。狙うのは
もちろん最高峰のプラチナだ。

合には、低・中所得者
層を対象とした住宅を
指す。

▼4 ウォーカビリティ
walkable（形容詞）歩
いていける、歩きやす
い、の意。Walkable
city：歩きやすい都市、
歩行者に優しい都市。
Pedestrian friendly
（ペデストリアンフレンドリー）
と同義。

▼5 センス・オブ・コ
ミュニティ
コミュニティ意識。自分
が帰属するコミュニティ
だという感覚。

パールディストリクトのランドマークの一つ、ジェイムソン・スクエアパーク

LEED ネイバーフッド・デベロップメント
LEED Neighborhood Development

ホイト社が申請中の「LEED ネイバーフッド・デベロップメント」とは、アメリカ・グリーンビルディング協議会 (USGBC) による建築環境性能評価制度 (LEED) の一種。LEED は単体の建物を対象とし、その環境性能を評価しランク付けを行う (いうならば、レストラン評価「ミシュラン」の建築環境性能版) ものだが、2007年、これに新たに街単位のカテゴリーが加わった。それが「LEED ネイバーフッド・デベロップメント」である。同協議会によれば、次の5D2Gが評価のポイントだ。

5D

◗ **Highly Diverse：高度な多様性**
職住遊学の複数の機能が混在し、四六時中多様な目的による往来が絶えないネイバーフッド

◗ **Moderately Dense：節度ある密集**
郊外住宅開発へのアンチテーゼとして、ヒューマンスケールの住宅密集度があるネイバーフッド

◗ **Designed for people：生活起点のデザイン**
豊かな機能性を発揮する公共空間を有するネイバーフッド

◗ **Destinations are easy to access：アクセスしやすい目的地**
大き過ぎないブロックサイズと広過ぎない街路で構成され、かついくつもの小さな界隈が連なり回遊しやすいネイバーフッド

◗ **Short distance to transit：往き来しやすい距離**
速くて便利な交通手段のあるネイバーフッド

2G

◗ **Green network：緑のネットワーク**
豊かな緑が街を包み、環境に負荷をかけないネイバーフッド

◗ **Green buildings：環境負荷の少ない建物群**
環境負荷を最低限に止める高効率な建物群が多く建つネイバーフッド

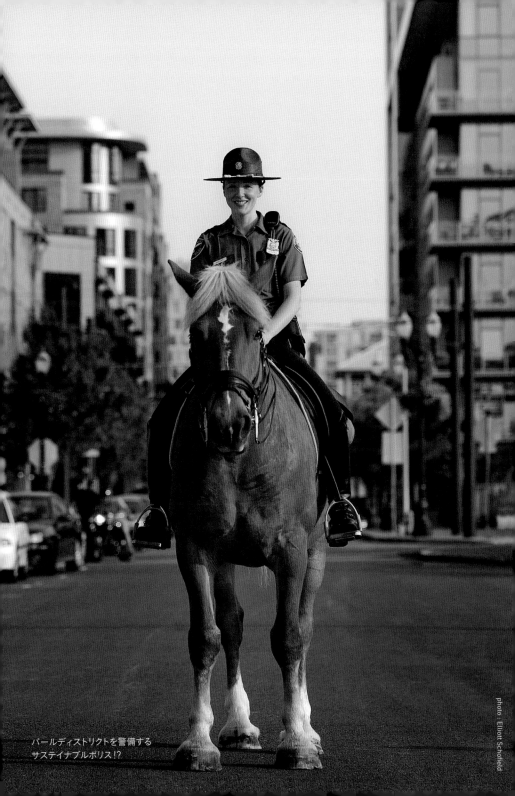

パールディストリクトを警備する
サステイナブルポリス！？

タナー・スプリングス・パーク

街を構想するにあたっては
デベロッパーのビジョネアーとしての
人生経験、見識、審美眼、知恵、
センスの総和＝都市生活者力が試される

30フィート以下の世界観

ホーマー・ウィリアムス
Homer Williams

ホイト・ストリート・プロパティーズ（ホイト社）の創業メンバーの一人で、パールディストリクトの産みの親とも称される伝説の人物、ホーマー・ウィリアムス氏。現在、WDD社チェアマンとしてロスアンゼルス・ステープルセンター地区[1]のジェントリフィケーションに情熱を傾けているホーマー氏にパールディストリクト[2]の開発理念を語ってもらった。

センス・オブ・プレイスを育む力

「我々がパールディストリクトに目をつけた当時はちょうど、郊外での生活よりも都心に住むことを志向するような、ヤッピーたちが目立ち始めた頃だった。その流れを察知してここに目をつけたのがそもそもの始まりだ。最初の段階では我々だって、ここに住みつく人口はもっと少ないと思っていた。でも途中から街の高密化に強烈な手応えを感じたのさ。今ではご覧の通り、見事なネイバーフッドができ上がっている。私はここをアーバンネイバーフッドと呼んで従来のネイバーフッドとは区別しているがね。

従来のネイバーフッドとは郊外の豊かな自然に囲まれた庭付き一戸建ての新興住宅街を指していた。それに対して、私のいうアーバンネイバーフッドとは、都市の高層ビルや喧噪、文化的刺激に囲まれた小さなコミュニティを指す。従来のネイバーフッドの親密さ・気安さを残しながら、顔ぶれが固定化してしまう閉鎖性やベッドタウンの牧歌的なのどかさを排除したものといえる。もちろんどちらを選ぶかは好みの問題だ。

ポジティブチェンジの実践者

では、このアーバンネイバーフッドづくり（Build the urban neighborhood）につ

▼1 ステープルセンター地区
WDD社は別のポートランド・ベースのデベロランド・ベースのデベロッパー社と組んでサウスグループ社を設立。ステープルセンター周辺のサウスパーク地区といわれる荒廃したエリアの都市再生事業を手掛けている。敷地面積は14 ha。手がかりとして、まず3棟の高層コンドミニアムから着手（同エリアにおいて20年ぶりの住宅開発となった）。都心居住を基本に生活支援施設、店舗そしてオフィスと多様性を増していく計画だ。住戸は最終的に2000戸の供給を予定している。コンセプトはグリーンアーバニズム・グリーンリビング。

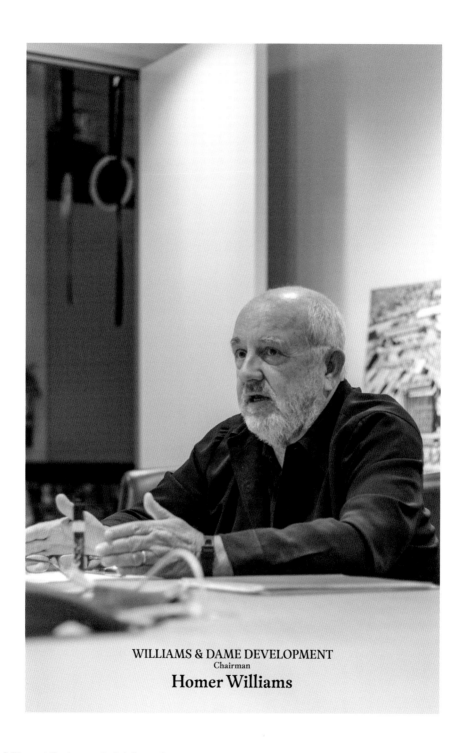

WILLIAMS & DAME DEVELOPMENT
Chairman
Homer Williams

いて重要な点を話そう。私は荒廃した土地や未だ手つかずの活用されていない「都市のウィルダネス（原野）」を見つけては、そこに将来の豊かなネイバーフッド像を思い描く作業、つまり"センス・オブ・プレイス"を発揮するこ▼4とを生き甲斐としている。

アーバンネイバーフッドの開発にあたっては、まず行政側と民間企業側との協力関係なしには到底実現は難しい。双方の期待や要求をテーブルの上に出し合い、一つひとつ協議を重ねながら、各々の目標獲得に向けて歩み寄っていくのさ。もちろん双方が達成したいビジョンを持ち合わせていなければ創造的な話し合いとはならないし、単に開発に対する抵抗勢力や許認可を出す指導的立場としてのお役所と、事業利益を追求するだけのビジネスマンという図式に留まっていては物事は前進して行かない。ポジティブチェンジは起こらないのさ。ポートランドの場合、市政府が押し並べてビジョネアーでなおかつ

優秀であるという点は強調できよう。

さて次に重要なのは、開発地と既成市街地とのコネクション、つまりスムーズなアクセスだ。パールディストリクトの場合、ペデストリアンフレンドリー（歩行しやすい）な歩行環境の整備とストリートカーの延伸によってそれを解決していった。

それから重要なのは、良いレストランと良いバーの存在だ。つまり生活に根づいたネイバーフッドレストランという社会資本整備だ。良いレストランの定義はいくつかあろうが、私が重視するのはローカルビジネス、インディペンデントであるかどうかだ。ローカルオーナーは文字通り店の顔である。訪れた客はまずオーナーの存在を意識する（ポートランドは元々ローカル意識が非常に強いところだ）。やがて顔見知りとなる。その結果相互に親密なリレーションが生まれてくる。もちろん話したくないときは話さないオプションだって担保▼5されている。そんなまるでスモールタ

▼2 ジェントリフィケーション
荒廃していた地域を再開発により再生し、人々が訪れたり居住するエリアへと変えること。スクラップ＆ビルド手法によるハードの刷新よりも、ニューヨークSOHO地区のように従来の建物等を活かしながら、居住者や産業が入れ替わるソフトの刷新を指す場合が多い。

▼3 ベッドタウン
大都市周辺に開発された郊外住宅地。サバーバンネイバーフッドの舞台。

▼4 センス・オブ・プレイス
場所に対する意識。自分が帰属する場所という感覚。

▼5 スモールタウン
田舎の町、田舎風の意。

048

ウンの日常のような体験を都市において味わえることが重要なんだ。ナショナルチェーンの場合、なかなかこうはいかないことは体験上君たちも理解しているのでは。これがアーバンエクスペリエンスでありネイバーフッドを実現する重要な要素となる。

建物よりも
建物と建物の間の空間

まだある。建築家の仕事は建物をつくることだが、私の仕事はコミュニティをつくることだ。ではコミュニティ意識を育むために大切な点とは何か。それは地上から30フィート（約9m）の間の世界で起こる日常だ。人々が地面を歩いている時、そこを安全と感じられるか、そこに楽しさを見出せるか、再び訪れたいと思うか、すべては30フィートの世界で決まる。建物はほとんど重要ではない。そこにコミュニティが生まれるかどうかは、建物以外の総ての質にいつも気を払っているのさ」

ことの方が大切なんだ。地面に足が触れる

れている瞬間の方が重要なのである。だからアートギャラリーやグッドレストラン＆バー、公園、オフィス、住宅、ヘアーカット、ホームファニシング、そしてコーヒーショップなどの混在によって生まれる多様な人々の往来によって生まれる出会いとその機会の創出が人々のコミュニティ意識を高めるんだ。

つまるところ、アーバンネイバーフッドにとって大切なのは、日常の生活であり、生活の充足だと言えるだろう。そのためには、住むには郊外よりも都市の方が格好の舞台となるんじゃないだろうか。だから私は建物はもちろんだが、それ以上に建物をとりまく環境の

古くからの倉庫を用途転換した住宅（写真手前右）と、新しい高層コンドミニアム群。街が新興富裕層やヤッピー（若い高度専門職ビジネスマン）ばかりになることの弊害を一番知っているのが、高層コンドミニアムに引越してくるヤッピーたちなのかもしれない

街のあちらこちらで見かけるギャザリング（集団）風景。こうして、ある個人から発せられたアイディアが都市の中で埋没せずに次々と伝播していく。あるポートランダーはこの状況を指して次のように解説してくれた。「ポートランドは今、街の人口密度が最適なんだ」

里山や野原の代わりにストリートコーナー
やウォークサイドテラスを遊び場に育つ子ど
もたち。でも車で少々走ればUGBに守られ
た手つかずの自然と戯れることができる。「都
市か自然か」ではなく「都市も自然も」のライ
フスタイル

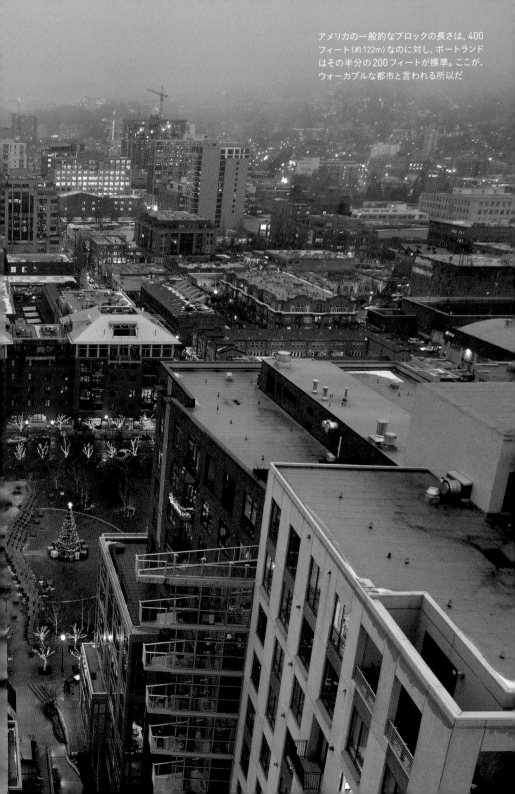

アメリカの一般的なブロックの長さは、400
フィート（約122m）なのに対し、ポートランド
はその半分の200フィートが標準。ここが、
ウォーカブルな都市と言われる所以だ

都市生態系の理想型

パトリシア・ガードナー
Patricia Gardner

パールディストリクトの住人たちは、その多くが文化・風俗に対する関心が高く、都市のざわめきの中での暮らしを好み、適度な連帯感を保ちながら、フレッシュな農作物とコーヒーにこだわり、フランクな社交が大好きで、スノッブになりがちなところを根っからのリベラルさと寛容性とで中和させる術に長けた、興味深い人たちである。

そんな彼らの素性を、建築家でパールディストリクト住人のパトリシア・ガードナーに聞いた。彼女は、PDNA[1]のボードメンバーでもある。

能動的な当事者意識

——コミュニティって言葉は今やかなり胡散臭いけど、悔しいことにパールを歩いているとそれを、つまりコミュニティ意識を感じてしまうのは、私が外国人の旅行者だから?

パトリシア(P) セルフセレクティング。パールに住んでいる人たちは、皆ここに住みたくて住んでいるの。始めからこのエリアは都心居住エリア、もっと言うならアーバン・ミクストユーズ・コミュニティだということを前提に移り住んだ人ばかりだわ。[2]

——選択的な移住ってわけだ。日本は出身地や土地に対する執着が今でも強くて、就職や転勤、結婚などのやむを得ない理由がなければ、大都市を除いて、中々新天地を求めて移住するケースは多々ない。それに対してアメリカの場合、自己選択による転居はよくあることなの?

P 国民性からくる差異については、私はコメントできないわ。でも私の周りを見回してみても、東部から移ってきた人、カリフォルニアからきた人、同じオレゴン州内から移動してきた人、様々よ。つまり、お互い同士が"知らない"ということを前提にしなければ、

▼1 PDNA
Pearl District
Neighborhood
Association
パールディストリクトコミュニティの維持・活性化に取り組む非営利組織。メンバーはパールディストリクト居住者、ワーカー、不動産所有者等で構成される。参加形態はボランティア。194頁参照。

▼2 アーバン・ミクストユーズ・コミュニティ
都心居住エリアにおける人種の雑多性を指す。

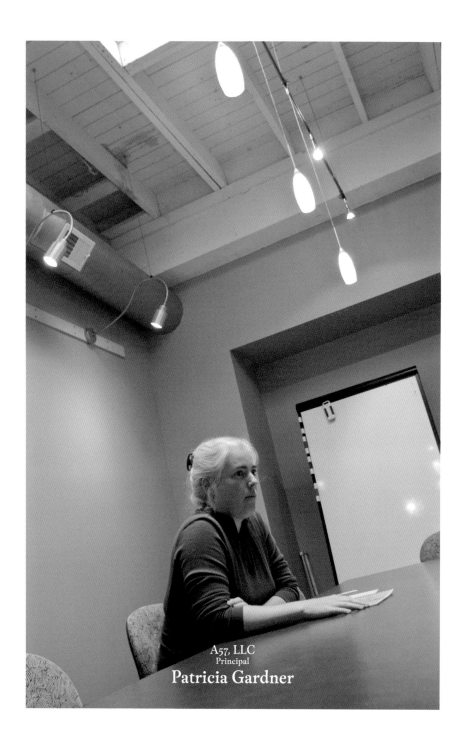

A57, LLC
Principal
Patricia Gardner

コミュニティ意識は生まれにくいんじゃないかしら。コミュニティをつくるという当事者意識を居住者それぞれがもっているんだと思うわ。

——なるほど、能動的な当事者意識ですね。私に一番欠けてるものだ。パールの場合、都市再生はブラウンフィールドというゼロからのスタートでしたから、移住者にとってはよいその意識が強いのかもしれません。コミュニティ意識の出自は分りました。では、このパールに漂う独特の緩い親密感というか、一つのテイストに根差した街のムードって、どこからきていると思う？

P　わたしたちはパールのコミュニティを、アーバンネイバーフッドと呼んでいるわ。あなたが感じているものと同じかどうかは計り知れないけど、新しい近隣住民のカタチであることは確かね。

——パールを開発したデベロッパーたちも盛んにそれを口にしてました。思うにアーバンネイバーフッドとは、人やコミュニティといった関係性を指す言葉なのか、それとも街という物理的な場所性を指すものなのか、今一つ分らないんだけど、アーバンネイバーフッドを定義してもらえませんか？

P　私は社会学者じゃないから、パールに則したアーバンネイバーフッドと規定した上で話させてもらえば、アーバンネイバーフッドは、3つの要素から構成されていると思うの。「ウォーカビリティ」「ミクストユーズ」「クリエイティビティ」の3つね。

——ではまず、「ウォーカビリティ」から。

ウォーカビリティ

P　アメリカのブロック（街区）は一般

的に一辺が４００フィート（約120ｍ）で構成されてることが多いの。でもパールを含むポートランド・ダウンタウンはその半分の２００フィート（約60ｍ）で街区が切られている。それがどういう効果をもたらすかといえば、単純に歩きやすいの。風景が他の街よりもテンポよく移り変わっていくから歩くことが苦にならない。歩く機会が増えれ

ば、当然人と会う機会も増えるわ。やがて顔見知りもできる。挨拶から会話する関係へと発展するケースだって起こり得るの。

──ちょっと待った。そうした近所付き合いとか、濃い近隣関係って、郊外住宅街の専売特許だったんじゃないですか？　結局一緒なの？

P 確かにサバーバン（郊外）は、低い人口密度、芝生のオープンスペース、若い夫婦と子どものニューファミリー、週末のガーデンパーティというように、ネイバーフッドコミュニティの典型のように思われているわよね。だけど、それは正確な描写ではないわ。現実のサバーバンライフは、毎日車に乗ってオフィスまで通勤して、帰ってきて家で食事をして後は寝るだけ。週末のバーベキューパーティでは、元々同質な世帯同士が集まるコミュニティだから、自然に差異性や優越感を覚えたいがための暗黙の品定めが始まる。やがてそれが相互に違和感をもたらし、近所同士の接点は失われていく。つまりトラディショナルなネイバーフッドの方が閉鎖的で風通しが悪い場合が多いのも事実よ。

——従来の伝統的な郊外ネイバーフッドは、実は空虚なコミュニティだったと。

P 1950年代から80年代のスプ

ロール化が急激に起こった時代、つまり車社会の時代に、私たちは「歩く」ことを避けてしまったために、歩くことによって何が起こるのか、歩かないことによって何が失われてしまうのかを忘れてしまったのよ。歩かないことによって確実にコミュニティ意識は失われた。でもパールの場合、ウォーカブルな街を意識的につくったから、都市の真ん中にありながら人と人との接点がとても多い。以前のトラディショナルなネイバーフッドよりも近所の人たちのことをよく知るようになる。それはパールに移り住んだ人たちが皆一様に驚くことよ。ウォーカブルなネイバーフッドは車社会に対するアンチテーゼでもあるの。

——しかも、都心だけあってそもそも色んな人たちが街に出入りするわけだから、無意味な比較なんて気持ちは起こらない。メンタリティとしては、むしろ積極的に違いを受け入れて、その

▼3 サバーバンライフ
郊外住宅地での日常的生活の意。

▼4 トラディショナルなネイバーフッド
郊外の庭付き戸建ての住宅街（サバーバンネイバーフッド）を指す。米国における典型的なネイバーフッド。

パールディストリクトのランドマーク「ジェイムソン・スクエアパーク」に隣接するイタリアンレストラン。年間を通じて雨の多いポートランドにおいて、晴れた8月は絶好のパティオシーズン

刺激を自らの糧としたい、と。

P　その通り。都市生活者の感受性ね。以前から

それが2つめの要素、「ミクストユーズ」につながるわ。例えば郊外住宅地のようなゾーニングタウン（この場合、住居専用の単一用途エリアの意）だと、中の人たちは固定されちゃうし、生活パターンも似通ってるから、サムシングニューやサムシングディファレントの出会いが少ない。でもパールのように職住遊が混在したミクストユーズの街だと、様々な動機でいろいろな人たちがここを訪れて歩き回っているから接点も多い。それだけじゃなくて、住人たちも街の中での手持ちの行き場所が増える。何せ建物の1階はカフェやレストランやブティックで占められているから。そうすると、人と会ったり刺激を受けたりする機会も自然と増えるわよね。さっきのサバーバンコミュニティの特徴と比べて、アーバンネイバーフッドの特徴は、必ずしも皆が知り合いの「身内」である必要がないってこと。つまり開放型のコ

ミュニティなのよ。これがミクストユーズネイバーフッドの豊かさよ。以前からミクストユーズ型開発の健全性については、いろんな場面で言われてきているけれど、ミクストユーズが新しいコミュニティ形成に役立つことを現実に実践してみせたのは、パールが最初じゃないかしら。

――閉鎖的なコミュニティに起こり得る過度な同調性とか義務的なつながり、強迫観念とは無縁な「都市らしさ」が効いてるわけですね。ところが、ここに集まる人には、「パールの空気を好む」という価値観の共有がある。その要さえ定まっていれば他人は他人のままでいられる。自立しながら連携するというような微妙なというか絶妙なバランスですね。

P　そう、だからその絶妙なバランスを成立させるだけの、パールディストリクトに固有の価値観、つまり「要役」

が必須となるわけ。それが「クリエイティビティ」よ。

アーバンネイバーフッドのカタリスト

P　アーバンネイバーフッドとクリエイティビティの関係は切っても切れないわ。コミュニティが形成される際の状況って言うのは、まず場所があるわよね。そこにアーティストがやってきて住みつく。パールディストリクトの場合、ご存知の通りかつては倉庫街だったから、アーティストにとってはロフトの宝庫だったの。そこで彼らは創作活動を始めるんだけど、創作活動以外の時間の過ごし方が上手いアーティストも少なくないわ。とにかく彼らのライフスタイルは、端から見てとても自由でしかもクールに映るのよ。そして住民たちはそれに感化されるところが多い。パールディストリクトの外の人たちにとっても、そんなパールが魅力的に映る。そして住んでみたいと

——お祭り好きは日本人にも多いです。

思う人たちが現れるの。こんな風にパールディストリクトの街の成り立ちはアートに依るところが大きいから、パールディストリクトの住人たちもアートコンシャスな人が多い。私を含めてだけれど、そういう人たちってだハプニングの気配は大歓迎だわ。常に刺激的なハプニングが街のどこかで行われている。常に街にザワザワとした胎動を感じることができる。街に文化的な活気がみなぎっている。とにかくパールディストリクトの住人はハプニングを享受する生活を志向しているの。これがアーティストやクリエイター、そして文化的なギャザリングを好む人々と街との関係よ。アーバンネイバーフッド同士が価値観をシェアできる具体的で確実性の高い触媒がそれ。パールディストリクトの住人にとって、文化的イシューはコーヒーと同じくらいデイリーニーズなの。

▼5 ハプニング
思いがけない出来事、事件。または、芸術家による偶発的な行為や出来事を呈示する芸術表現。ここでは、文化的イベントや行事の意。

Ziba Design

「火事とけんかは江戸の華」っていう感覚と似てるかもしれない。クリエイティブとは言えないけど（うまく訳せない…）。その意味では、パールの街の真ん中にワイデン＋ケネディがいたり、PNCA（パシフィック・ノースウエスト・カレッジ・オブ・アート）や Ziba Design [6] があったりと、アートやクリエイティブシンカーの存在が視覚的にも象徴的だし、街のムード形成にとても効いてる気がします。

P　あと、これはパールディストリクトに限った話じゃないんだけど、もう一つアーバンネイバーフッドにとって重要な要素として、市民意識、自治意識があるわ。

——それはポートランドに来て、いろんな人と会って話を聞くにつれて非常に感じるところです。あなただって、今こうして PDNA（パールディストリ

クト・ネイバーフッド・アソシエーション）の一員として、街に関する取材に快く応じてくれている。もうすぐ2時間が経っちゃいますね。

P　ポートランドでは、自分個人の活動が街の政治や環境形成に影響力をもつってことを自覚している人が多い。それが街づくりや色んな催しに積極的にボランティアで参加する人が多い理由、エンジンとなっているわ。それがポートランダーの平均的な意識よ。

——マックス・ウェーバー [7] が、都市の本質とは「一つのまとまった団体としての性格を有してること」「市民という身分的資格の概念が存在すること」って言ってたらしいけど、パールはまさにその体現だね。みな積極的にここを選んで、住んだり・オフィスを構えたり・遊びにきてるわけだから、街に対する愛着が強い。最初に感じた街に対する憧れが、居を構えることによって

▼6 Ziba Design
パールディストリクト内に本社を置く、1984年設立のデザインコンサルタント＆デザイン会社。クライアントの多くはマイクロソフトや GE、Samsung 等グローバル企業。

▼7 マックス・ウェーバー
1864〜1920年。ドイツの社会学者・経済学者。世紀末から世紀初めにかけて活躍。該博な知識と透徹した分析力によって、法学、政治学、社会学、宗教学、経済学、歴史学などの分野で傑出した業績を残し、また鋭い現実感覚によって当時のドイツの後れた社会と政治を批判して、その近代化に尽力した。（出典：『日本大百科全書』小学館）

自慢や誇りに変わっていって、帰属意識になってやがて自治意識へと自然と移行していくような、端から見ていてそんな気がする。ちょっと格好良すぎる気がしないでもないけど……。

P　それとオレゴンの特殊性も多分にあると思うわ。あなたが言うようには、事は上手くは運ばないものよ。とにかく、パールディストリクトはヒューマンスケールでウォーカブルで高密な都市であるために、地元住民にも恐らく旅行者にとっても非常にインティメシー（親近感）を感じ易い街だということとは言えるわね。パールディストリクトの住民はその多くが、バイオダイバーシティ（生物多様性）的なリレーションシップの大切さを実感している。どうやらそれがアーバンネイバーフッドの本質かもしれないわね。そしてそれがパールディストリクトのユニークさと

いえるんじゃないかしら。

——スター建築家の手によるスペクタクルな建物はない代わりに、100年前の建物を再利用したクールなオフィスやコミュニティフレンドリーなLEEDプラチナ認証のミュージアムを使いこなし、ギャザリング（集会）が同時多発するハプンしている街。

日本のこれまでを、農耕社会の同調的コミュニティから抜け出し、都市の時代へと移行し、個が海原に放り出されはしたが、今度はそこで中々上手い具合の社会性（結びつき方と距離の取り方）を身に付けられずに過ごした、都市生活初心者段階の「都市文明1.0」だとしたら、パールディストリクトのそれは、個人と個人が巧みにつながり柔軟に離れる、自立していて応用力の効いた、「都市文明2.0」に見えるのである。雨さえ多くなければ私だって……。

▼8　バイオ ダイバーシティ（生物多様性）
生物多様性とは、自然の多様性を生態系レベル、種レベル、遺伝資源レベルの3つのレベルで捉えた、生物の豊かさを包括的にあらわす概念。その保全は食料や薬品などの生物資源のみならず、人間が生存していく上で不可欠の生存基盤（ライフサポートシステム）としても重要。ここでは比喩的に用いられており、一律でない多様なタイプの人々が相互を尊重しながら一つの全体を形成しながら居住している様を指す。

レストランSungari Pearlのテラス席。中
華料理とパシフィックノースウエストが融合
した、地元で評価の高いオーガニック・レス
トラン

アーバンネイバーフッドの
つくり方とつかい方

Gerding Edlen 会長 マーク・エドレン

photo : Dan Bihn

パールディストリクト再生の先駆けとなった、「ブリュワリーブロック」。この開発を手がけたのが、ポートランドに本社を置く1996年創業のデベロッパー、ガーディング＆エドレン(以下、GE)だ。パールディストリクトのアーバンネイバーフッド化を方向付けた革新的都市チェンジメーカーである。創業者で会長のマーク・エドレン氏に今後のイノベーション経済時代の都市再生についてノウハウを伺った。

20分圏ネイバーフッド

——ガーディング＆エドレン(以下、GE)はアーバンネイバーフッド開発における全米のトップランナーだと聞いています。そこで、御社の考えるアーバンネイバーフッド型都市再生の手法について、お聞きしたいと思います。

マーク(M) 我々GEが、アーバンネイバーフッド開発に関して信条としている原則が4つあります。①アーバンインフィル、②サステイナビリティ、③ミクストユーズ、④キュレーションです。特に私は、石油が環境、富の再分配、環境汚染、差別の助長など、文明社会の様々な側面において空虚をもたらす要因だと考えています。

——ではまず、アーバンインフィルからご説明頂けますか。

M GEが都市を開発するにあたって重要視しているのは「20分圏のネイバーフッド」です。これは、自宅から徒歩20分圏内に職場や学校、スーパーマーケットなどの生活基盤が全て揃う生活を意味します。もしそれが不可能であれば、MRTや自転車を使って20分圏内で済む生活の実現を考えます。つまるところ車の必要性のない生活の創出です。

ポートランドで言えばパールディストリクト、ウェストエンド、ノースミシシッピ、ホーソン、ディヴィジョン等の各ネイバーフッドがそれに当たります。ビジネスの中心地である必要はありませんが、そこの住民が「20分圏内」で完結する生活を送れることが重要です。たとえば、若い世代は従来のビジネス街には興味を示しません。我々はここから4ブロック先の倉庫街が、歴史的な建物が多くて気取りがなく、より「本物（オーセンティシティ）」であるため、今後のビジネスの中心地になっていくと考えています。

若い世代はこの部屋（GE本社）のように、生で（Raw）未加工の空間を求めているのだと思います。つまり、コンクリートであれ鉄であれ木材であれ、建物の構造体に原材料のありのままの姿（オーセンティシティ）が見えるということです。2000年にここからGEがここから数ブロック先に開発したブリュワリーブロックでさえ、今では磨かれ過ぎて

（加工され過ぎて）いると言われてしまいます。もちろんブリュワリーブロックの開発自体は大きな成功を収めましたし、我々もそれに大きな誇りを持っています。ただし、これからは住居であれオフィスであれ、リテイルであれ、若い世代はより本物を求め、他者とコラボレートする働き方を全て自分たちの中でこなそうとしますが、彼らは廊下の向かい側やストリートの反対側の人々と協働しようとします。GEは彼らの声を聞き、彼らがどんな場所に住み、働きたいのかを学びます。それを元に新しい建物を建てるのか既存の建物をリノベートするのか決定します。

それは、現代の都市生活者が金銭的ではなく文化的な意味を求めて相互に緊密に交流し合うことに価値を見出している結果だと思います。人々は私たちが今こうしているように、集い、互いにアイディアや経験、情報を得たり交換したりする場所を求めているので

Mark Edlen
ガーディング・エドレン共同創業者、会長。20年以上にわたりミクストユーズ開発を始めとする様々な不動産開発を通して、サステイナブルなコミュニティの創出に従事。環境共生型都市開発の第一人者として知られる。また「20分圏ネイバーフッド」コンセプトの生みの親でもある。

068

す。これからの都市開発や都市経営は全てそこに集約されると、我々は考えています。

ネイバーフッドの誕生

——アーバンネイバーフッドを創ろうとする時、どこから手をつけますか。あるいはポイントは何ですか。

M　交差点には4つのコーナーがありますが、それぞれにレストランやバー、カフェなどを誘致すると、突然その横に10ユニットほどの住居が開発されたりします。あるいはオフィスビルが生まれたりします。それらは新築ばかりとは限りません。倉庫がリノベーションされたものかもしれません。そのようにして街が広がっていきます。交差点の4つのコーナーのうち、1カ所カフェができただけでは人の流れは生まれません。2軒、3軒……まだまだ。4軒全て揃って、はじめて人が味をもつのです。

その交差点を歩いて散策してみようという気分になるのです。やがて路面店は隣接する建物にも広がって一つのウォーカブルなストリートとしてつながっていきます。そしてそれをポートランド独特のDIY文化が後押しします。私が最初に購入した自宅を自分で改装したように、今の若い世代もネイバーフッドに移って古い家を購入し、リノベートして復活させるのです。

もう一つ、ネイバーフッドを生き生きとさせる大きな要因として信号無視ができるかどうかがあります。つまり信号を無視しストリートを堂々と歩くことができるということは、車ではなく歩行者がストリートや歩道の主役であることを意味します。あるいは、スケートボーダーや自転車に乗る人たちが車に怯えずにストリートを活用できるかどうかがアーバンネイバーフッドを生むために重要な意

Gerding Edlen
ガーディング・エドレン

1996年設立のガーディング・エドレン社は環境共生型のオフィス、住宅、ミクストユーズ、都市開発を専門とする不動産デベロッパー。特に環境と社会的責任に考慮した開発実績の多さで有名。サステイナブル型開発においては、75件以上のLEED認証を持つ。全米における環境共生型開発のリーダー的存在として知られている。

サステイナビリティ

――リノベーションという話がよく出ますが、アーバンネイバーフッド開発におけるサステイナビリティの実装方法についてお聞かせ下さい。

MGEでは75棟以上の建物でLEED認証を受けています。またネイバーフッド単位で認証審査を受けているプロジェクトもあります。また、上下水処理については「ネットゼロシステム」を導入しています。これは建物が使う水の一部を雨水から取り込み、敷地から出る排水は全て処理を施して綺麗な水にしてから戻すシステムです。エネルギーに関しては現在のところ従来値と比べ60％の削減に成功しています。新たなプロジェクトでは80％の削減を見込んでいます。

GEにとって非常に重要な点は、建築物やネイバーフッドは100年から

200年単位のライフスパンで考えなければならないということです。携帯電話のように数年で捨ててしまうような消費財とは異なります。つまりコミュニティに対する責任としてサステイナビリティは重要視されるのです。

ここ10年間で気づく変化は、クライアントが高い建築環境性能を誇る開発を求めるようになったことです。クライアントはLEEDプラチナ認証をより低コストで得る術や歴史的建物のリノベートを期待しています。なぜなら彼ら企業が雇用したい若いエンジニアたちはサステイナビリティを重要視しているからです。それはマンションであれオフィスであれ同じことです。若い世代は「20分圏のネイバーフッド」のように職住近接の都市生活とサステイナビリティを実感できる環境を望んでいるのです。もはや車が必要な郊外での生活は時代のニーズではないのです。

デザイン、デベロップメント、キュレーション

——開発後におけるデベロッパーのコミットメント度合はいかがでしょうか。

M GEは近年、開発後の都市生活における2つの側面に焦点を置き始めました。一つはキュレーションです。これは、地元での生活環境や顧客ニーズに持続的に適応していくことであり、何より重要なことはコミュニティ意識を醸成し人々をつなげることを指します。

エースホテルを例に取ってみましょう。客室内に掲げられている写真は100ドル程度の物ですね。GEが建築家と探せば1万ドルの写真を選びます。それは私の世代にとっては価値あるものですが、若い世代にとってはこの100ドルの写真の方が価値があるのです。カフェであれレストランであれイベントであれ、規模の大小に関わらず、人々が集いたくなり再訪したく

なるような空間をつくり、コミュニティ意識を醸成し、継続的にそのコミュニティを育てていくプロセスこそが、私たちの考えるキュレーションです。つまり「20分圏のネイバーフッド」を実現するための最後のピースがこのキュレーションなのです。

——ここでいうキュレーションとは、テナントリーシングを含みますか。

M はい。もしエースホテルが私の所有であれば、ここにスターバックスを入れることもできます。しかしそうではなく、エースホテルはここにスタンプタウン・コーヒー・ロースターズを選びました。スタンプタウンの方がスターバックスよりもこの場でコミュニティを生み出すのに適しているからです。

——しかしデベロッパーの立場としては、そうした独立系企業はスターバックスと比べ支払える賃料に差が出ますね。

M　もちろん、そのリスクはあります。もしかしたら30%ほど下がるかもしれません。では、そのコーヒーショップを1階にして、私のオフィスが10階にあるとします。若い世代の欲しているオフィススペースの方でより多くの賃料収入が得られます。結果としてスターバックスを入れた場合と比べて、同等以上の収入を得ることができます。実際に先の経済危機の際、GEがキュレーションしたブリュワリーブロックとインディゴ・ハイライズ・アパートでは一つの空室もありませんでした。

分配されたインフラ

M　もう1つはエコディストリクト化[2]です。これはGEが今後深めていく重要なテーマとなります。

——サステイナビリティはクライアン

ト（企業）の側だけでなくエンドユーザー（就労者、消費者）にとっても重要な意味を持つとお考えですか。

M　私が大学院を卒業した1970年代当時、学生たちの大きな関心は公民権問題とベトナム戦争でした。現在の学生たちにとっての関心事は環境フットプリントなどであり、それは東京でもロンドンでも同様ではないでしょうか。ポートランドではその意識はより高いように思います。たとえばポートランドの法律事務所では環境問題に非常に敏感ですが、ロサンゼルスでは優先的なテーマにはなりません。

また、サステイナビリティほど消費者に見えにくく、触れにくいものもありません。建物の正面ドアにLEEDプラチナ認証という看板を掲げることはできます。しかし、どこを見廻しても、何千ガロンという雨水が再利用されている事実を垣間見ることはできません。太陽光がこの街の屋根にさんさ

▼2　エコディストリクト
地区単位で給排水、エネルギー、廃棄物等を共有・配分し合うことで、水、エネルギー利用のネットゼロを目指す環境共生型都市インフラシステム。

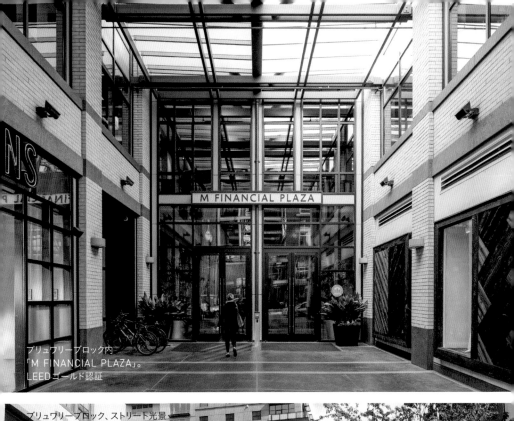

ブリュワリーブロック内
「M FINANCIAL PLAZA」。
LEED ゴールド認証

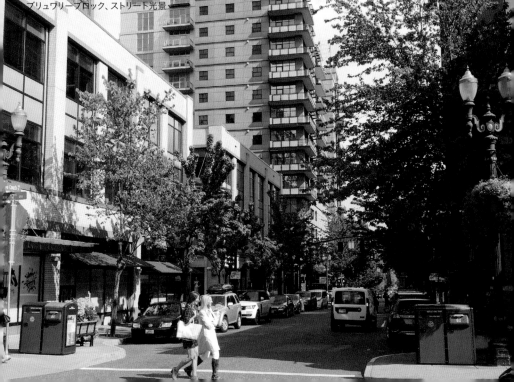

ブリュワリーブロック、ストリート光景

んと降り注いでいるのを確認すること
もできませんし、この部屋で使われて
いるフローリングがウィラメット川の
川底から引き上げられた物であるとい
う事実を知る由もありません。またこ
の柱が米国からアジアへの輸出に使わ
れていた廃棄寸前のパレットから作ら
れていることを知ることもできません。

エコディストリクトに話を戻しま
しょう。GEはこれまでの経験からエ
コディストリクトについて多くを学び
ました。日本での原発事故や東海岸の
ハリケーン・サンディの悲劇、北京の
公害の恐怖などを見てきました。さて、
私がエコディストリクトとは何かと問
われれば、それは「分配されたインフ
ラ」と答えます。

　私たちが実現したいのは、コミュニ
ティで使われる水の全てを雨水を濾過
したものにすること。排水・汚水は処
理をしてきれいな水として川に戻すこ
とです。またエネルギーはすべて地区
内で、可能であれば再生可能エネルギー
によって作り出して賄うことです。
これはミクストユーズ開発によって
達成できます。オフィスは平日の日中、
商業施設は週末や夕方、住居は夕方と
いうように、水やエネルギーのピーク
需要が業種によって異なります。それ
らを地区内で融通し合うことで、給排
水、エネルギー、ゴミなどを再活用し
自足自給することができます。

公共とのコクリエーション

——もう一つ質問です。ポートランド
はPPPの取り組みに積極的ですが、
街を開発する際、あなた方デベロッパー
と市政府はどういったギブアンドテイ
クをし合うのでしょうか。

M　ブリュワリーブロック開発の際、
かつてのビール醸造所の屋上にあった
大きな貯水タンクを雨水貯蔵タンクに
再利用しようと提案したのですが、市
から法規制上できない旨の指示を受け

ました。そこで市・州政府に働きかけて配管規制を変え、雨水を中水としてトイレで使用できるようにしました。そのかわり市からは、「このトイレの水は雨水を再利用して使っているので飲めません」という表示をつけるよう義務付けられました（笑）。

こうしたトライ＆エラーを踏まえて、今日では環境共生的なシステム整備に関わるコストを軽減し、さらに掛かった費用とそこから生み出される新たな付加価値とを相殺できないかの話し合いをしています。長期的展望では下水管理やエネルギー管理の整備にかかる費用をデベロッパーの会計上オフバランス化し、コストで焦げ付きを起こさずに所有・運用し、公益事業のようにエネルギーを生み出し、それによって利益を得る別の実体を作れないか模索しているところです。

── PPPというより、コクリエーションですね。ポートランド発のこの

エコディストリクトの取り組みは、ワシントンD.C.でも採用され目下工事中だと聞いています。大気汚染と水不足が深刻な中国都市部でもブームになることを切に期待するところです。また、鶏と卵の例えになってしまいますが、ポートランドの専売特許でもある「20分圏ネイバーフッド」の拡大は、デベロッパーや都市計画家のお仕着せではなく、才能ある若者たちのニーズによって定着していることも分かりました。特にテック系、クリエイティブ系の若いビジネスマンは、金融系ビジネスマンのようにオンとオフを明確に分けない働き方を志向するのが特徴ですよね。働くことを楽しみ、遊びの中からアイディアを思いつく。QOLもいいけど、若いうちはクオリティ・オブ・クリエイティビティ（QOC）の充実の方が生きがいや達成感を実感できる。「ほっこり系」のコミュニティ論とは無縁のポートランドのタフさを実感できとても嬉しいです。

ネクストフェーズ・ポートランド。
PDCの解体、プロスパーポートランドの誕生
Prosper Portland

photo : Dan Bihn

日本の企業、行政主体にとっても詣出先の1つであったPDC（ポートランド市開発公社）が
2017年5月、59年の歴史に幕を降ろしプロスパーポートランドへとその姿を変えた。
都心中心の都市再生により生じた数多くの社会的課題への反省から、
業務内容の刷新に迫られたのが理由だ。

負のレガシー

PDC（ポートランド市開発公社）が誕生したのは今から約60年前の1958年。ポートランド市の都市再生および経済開発を専門に行う市の外局として創設された。これまで数多くの都市再生を手掛けてきたが、特にパールディストリクトやサウスウォーターフロント開発においては、全米でも成功事例として知られた存在となっている。しかしポートランド市民にとって、PDCの歴史は必ずしも「我々の味方」ではなかった。

その発端の1つは、PDCが70年代に手掛けたノースイーストサイド地区の都市再生事業にある。元来そこはアフリカ系アメリカ人が多く住むネイバーフッド。そこを彼らを立ち退かせた上で大規模な複合開発を決行してしまった。それ以来今日に至る約40年間にわたり、市民の胸の内には、PDC

はネガティブな存在として記憶され続けたのである。プロスパーポートランドのプロジェクトマネージャー、マイケル・ガートン氏は次のように話してくれた。

「90年代のパールディストリクトやサウスウォーターフロントなど、それまでブラウンフィールドだったところをPDCの手によって再生し、人が住み、働き、遊ぶ新たなネイバーフッドとして蘇らせた評価されるプロジェクトもあるにはありました。しかし40年前の負のレガシーはそれ以上に大きかったのです」

ポートランドが直面する社会的課題

サンフランシスコ、ポートランド、シアトルのアメリカ大平洋岸北西部の各都市はこの10年間で飛躍的な経済成長を遂げた。サンフランシスコは住宅価格の中央値が百万ドルに達し、今や全

米で最も不動産の高い都市として知られるようになり（10万ドルの高額受給者でも家が買えない）、シアトルはアマゾンやマイクロソフトに代表されるテック産業の隆盛により、住宅賃料がこの7年間で57%上昇した（ロイター発）。一方ポートランドでは2001年から2014年の間に、1人当たりGDPが48%上昇（同サンフランシスコ16%、同シアトル18%）するなど、全米でもトップクラスの成長率を記録。その結果、今やポートランドは2つの異なる顔を持つ都市になり果ててしまったという。1つは主に白人男性を中心とするソフトウェアやテクノロジー系企業がもたらす高額所得者層中心社会。もう1つは、高額所得者向けの住宅開発が盛んになるにつれ、外へ外へと追いやられることになったアフリカ系アメリカ人他、マイノリティ社会である。結果として、立ち退き問題、ホームレスの増加、アフォーダブル住宅不足と言ったラピッドグロース（急速な経済成長）がもたらす

負の影響に直面しているのだ。ガートン氏は言う。

「過去に、私たちはアーバンリニューアルという経済成長のためのツールを不適切に用いてきてしまったという負のレガシーがある。そして現在は、それがもたらした深刻な社会的課題を抱えてしまっている」

ポートランド、第2のフェーズへ

2015年、PDCは「ポートランド5カ年戦略計画」を発表した。記載されている内容は、これまでのアーバンリニューアル計画（2010年策定の「ポートランド5カ年戦略計画」による）を全て見直し、どのエリアにどのような投資をすべきかを方向転換するものとなった。方向転換の向かう先はずばり、マイノリティ社会の繁栄である。PDCからプロスパーポートランドへの抜本的体制改変もその戦略計画の一環として行われることとなった。

「重要なのは、プロスパー・ポートランドの投資の対象は誰かと、つまり受益者は誰かという点です。今回私たちはマイノリティ、女性、有色人種に対象を変える方向転換をしました」（ガートン氏）。

2010年にPDCにより策定されたポートランド5カ年戦略計画は、当時の景気後退の状況を反映し、雇用創出、経済成長に主眼が置かれた内容であった。時まさにサブプライムローン危機、リーマンショック、世界金融危機といった不況真只中で練られた戦略だ。その甲斐あって、何とか止血をし、失業率を低下させるに至ったポートランドは、今度は予想に反し、ゆっくりとマリファナを吸い込む余裕もなく（2016年オレゴン州は成人使用が合法化）、近年は年間4万人以上（市郊外を含む）の移住者をかかえる急成長を果たす都市となった。ちなみにTVショー「ポートランディア」の放映開始は2011年。現在アメリカではシーズン8が放映中だ。そこで、「繁栄を市民全員で分かち合うことをゴールに定め直した」（ガートン氏）のだと言う。

その象徴的な例が、2017年のアマゾン第2本社誘致競合におけるポートランドの提案内容だ。全米中（カナダ、メキシコを含む）から238の誘致提案が集まったが、その中身は熾烈なインセンティブ合戦の様相を呈している。ところがポートランドのそれにはインセンティブの文字はなく、テック巨人アマゾンに対し、「我々のパートナーとなって、市が抱えている社会的課題を一緒に解決しないか」という誘いであった。

「私たちが今取り組むべきことは、10万ドルクラスの高額所得者の数をさらに5万人増やすことではなく、都市が抱えている課題をアマゾンが持つイノベーティブなアイディアや先端的テクノロジーを駆使しながら解決していく（ガートン氏）。

右上：2017年1月に開催された「ウーマンズマーチ」
右下：2016年11月、トランプ大統領決定に抗議しての道路封鎖デモ
左上：急増するホームレス
左下：2017年2月、黒人人権擁護運動が過激化しデモ隊と警察隊が衝突

photo : iStock.com/kosamtu

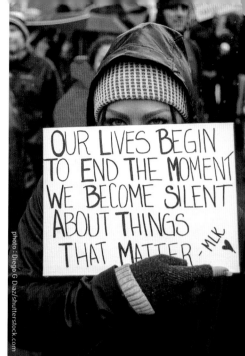

OUR LIVES BEGIN TO END THE MOMENT WE BECOME SILENT ABOUT THINGS THAT MATTER - MLK

photo : Diego G Diaz/shutterstock.com

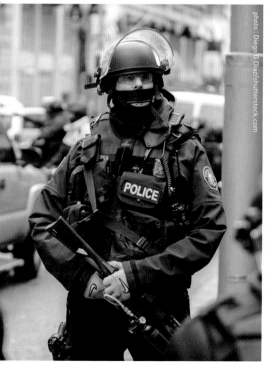

photo : Diego G Diaz/shutterstock.com

photo : Diego G Diaz/shutterstock.com

もちろん、シアトル所在のEコマースの巨人が、シアトル同等の規模を誇るとされる第2本社を隣接する州のオレゴンに設置するはずはないという諦めはあったであろう。しかしポートランドは今、かつての都市再生戦略が功を奏したおかげで、その弊害とも言える大きな課題に直面し、PDCは59年の歴史にピリオドを打つ必要に迫られたのである。

今後プロスパーポートランドは都市再生事業の面では対象エリアをアーバンセンターから市郊外のネイバーフッド開発へと矛先を変え、経済開発事業の面ではマイノリティや女性が経営するスモールビジネス支援を中心に行っていくという。ポートランドは今、明らかに次のフェーズへと変革の時期を迎えている。

2章

Chapter 2_Happiness by Creativity

ハピネス・バイ・クリエイティビティ
新しいウェルビーイングのかたち

実験する精神、実験を受け入れる精神

才能があつまるところに
企業はあつまる

　ポートランド市は企業誘致にも増して、才能豊かな人材の獲得に何年も掛けて取り組み、それを達成した。近年では1日あたり100人強もの若者がこの街に移住している。だから近年のポートランド市を形容する惹句は次のようになる。

「全米で最も急激に労働人口が増加した都市圏」「全米で最も急速にGDPが成長した都市圏」

「アメリカ西海岸で最も法人税がビジネスフレンドリーな州」。

　では、いかにして、ポートランド市は才能ある人材を集めたのか。創造性豊かな人は何に惹かれ何を好むのか。その前に、2017年に全米中を沸騰させたアマゾン第2本社新設プロジェクトから、今、テックジャイアントが街

に何を求めているのかを探ってみたい。

　同プロジェクトは、アマゾンが北米中の都市を対象に第2本社建設地の立候補を呼びかけたもの。

　アマゾンが示す誘致条件は多岐に及んだが、ベースとなる方針は次の内容であった。「人口100万人以上の大都市圏」「安定してビジネスフレンドリーな環境」「優秀な技術系人材を魅了する街」「誘致に大きなビジョンと創造性を描くコミュニティ」。中でも重点を置いたのが、巨大企業を支える質の高いテック系人材のストックだ。アマゾンは誘致を希望する自治体に、テック分野の人材プール状況に加え、企業経営、会計、法律顧問などエグゼクティブ人材についても言及。同社のこうした人材確保の姿勢は徹底しており、地域の大学や研究機関と提携したプログラムの有無や関連大学のリスト、学位を持つ卒業生の人数を過去にさかのぼって回答するよう要求した。さらには、小学校から高校までの期間にコン

ピューターサイエンスに関連するプログラムを自治体が設定しているかなど、長期にわたって安定的な人材供給ができる態勢を整えているかどうかまで記させるものであった。加えて、「我々の膨大な数の従業員が、生活を満喫し、余暇を楽しみ、教育の機会に恵まれ、高い生活の質を享受できることが条件」とアーバンアメニティ資本の重要性を強調することも忘れなかった。

翻って、ポートランドだ。現地の起業家は、街のクリエイティブな状況を次のように説明してくれた。それによるとポートランドが特別な点とは、①優秀なクリエイターが多いということではない。②それにも増してクリエイターもそうでない一般市民も、生活を含めたさまざまな場面で創造的チャレンジを試みている人が多い。③その結果、多くの市民が生き生きと暮らしている。④街にはそういう取り組みが可能な場と機会がいろいろと用意されている。

いる。そして何より、印象に残ったのは次の一言だ。「ポートランドはまだ160年の歴史しかないから、街自体が率先して実験中なんだ」。リビングラボそのものである。

自らチャレンジする人は、チャレンジャーを受け入れる人でもある。チャレンジャーを受け入れる街は、自らチャレンジする街でもある。チャレンジャーはチャレンジしている街を好む。人皆同類を好むからである。

ワークライフバランスを超えて

日本のデベロッパーの知人が以前こう話してくれた。「かつて、外資金融系で働くビジネスマンは、「work hard, play hard」。早朝から夜遅くまで目一杯働き、その代わりオフは思いっきり楽しむ。一方、近年のテック系クリエイターは、オフィスに遊びの要素を持ち込み、オンとオフの境界をいかに曖昧にするかに注力している」。創造的破

壊を高頻度で求められる生業の人たち
にとって、もはや仕事と遊びは分かち
難く地続きとなりつつあるようだ。

ポートランドでも、何度も同様の意
見を耳にした。「ワークライフバランス
はもう古い」と。どうやら、彼らは金
儲けも大事だけれど、それ以上にモノ
づくりの新しいプロセスを学んだり、ス
キルを身につけたりする方を優先する
らしい。まるでビジネスよりもアート
を選択したかのようだ。そして彼らは、
決まってこう続ける。「モノづくりって
そういうことだろう。ポートランドに
は好きなことを探求する。つまり仕事
にする人が多いんだ」。

「大企業で週60時間働くより、自分の
好きなことを仕事にして、その結果60
時間以上働いたとしても苦じゃないよ
ね。自分の好きなことをしていれば、仕
事っていう感覚じゃなくなる。そもそ
も大企業って、"必要な物"じゃなくて、
"売る物"を作っているんじゃないか。
僕らは永く使われる定番を作りたいん
だ。そしてそれを"売る"というより、
同じ価値観を持つ人たちと、その内容
を一緒に探求していきたいと思ってい
る」

ポスト大量生産型経済であるアルチ
ザンエコノミーの真骨頂だ。生活の質
と創造性とは表裏一体の関係であるこ
とをうかがい知ることができる。

クリエイティブコミュニティの
ゴッドファーザー

ジョン・ジェイ
John C. Jay

かつて倉庫街だった名残でいわゆるロフトセントリック産業の多いパールディストリクトの中でも一番強いオーラを発しているのがワイデン＋ケネディ（以下W＋K）だ。クリエイティブエージェンシーのトップブランドであり、世界7都市に拠点を置くグローバル企業の本拠地がここポートランドのパールディストリクトにある。街とクリエイティビティとの良好な関係性について、W＋Kグローバル・エグゼクティブ・クリエイティブ・ディレクターのジョン・ジェイ氏に話を聞いた。

アーバンパイオニア

—— W＋Kは、かなり早い時期からここパールにオフィスを構えていると聞きましたが、ここを選んだ理由と当時の街の様子について教えて下さい。

ジョン（J）　W＋Kがポートランドのダウンタウンからここに移ってきたのは1988年のこと。当時のパールは都心隣接地でありながら、全く手付かずのインダストリアルエリアでした。既に数軒のアートギャラリーとアーティストが住むロフトはあったものの、エリアとしては未開拓地といっても過

言ではないでしょう。今いるこのオフィスも元は氷の貯蔵庫で、窓は無く暗いじめじめとした大空間でした。今では想像できないかもしれませんね。多くの場合がそうであるように、物事の最初の開拓者、つまり何もなかったところに乗り込んできて、最初に事を起こすのは、若いクリエイティブな人種やアーティストであることが多い。まさにパールもそうで、当時クリエイティブなコミュニティが萌芽する気配が漂い始めていました。だから我々もこのエリアに可能性を見出したのです。その意味ではW＋Kもパールに新しいエネルギーを持ち込んだパイオニアの一人と言えるかも知れませんね。

▼1 ロフトセントリック産業
オフィスまたは、生活環境としてロフトとの親和性の高い業種との意。今でいうところのクリエイティブ産業に近い。

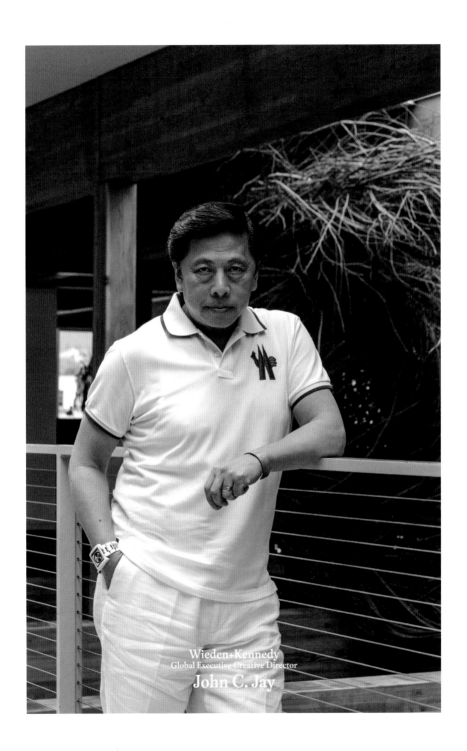

Wieden+Kennedy
Global Executive Creative Director
John C. Jay

——移転当時、既にナイキに代表されるようなグローバルブランドのクライアントを多数もつ、成功した企業であるW+Kが、ダウンタウンの高層オフィスビルではなく、当時まだ荒れ果てた発展途上のエリアを選ぶところに御社の企業文化が見え隠れしますね。

J 我々のビジネスはストリートカルチャーと密接につながっていると信じています。さらに言えば、我々のビジネスはユースカルチャー（若者文化）を基軸に成立しているといってもいいでしょう。W+Kにとってビジネスとカルチャーは切っても切れない関係なのです。だから我々は常に新しいカルチャーが生まれるところ、カルチャーのエネルギーに満ちたところにしか興味がないことは確かです。

——金融マンや法律家の多いウォール[2]ナットエリアでは窒息でもしそうな勢いですね。

J これはW+Kのスピリットの一つでもあるのですが、我々は常に社会とシームレスにつながっていなければならないと考えています。だからオーガニゼーションマン[3]が多く生息するエリアにオフィスは設置できないのです。さらにオフィスの中も、単にビジネスのためだけの空間であってはならないと考えています。例えばこのポートランド本社では、社会的課題に取り組んでいる3つのNPO組織にスペースを提供しています。それは決してCSRやパブリックイメージが目的ではありません。オフィスは現実社会のアナロジー（類推）であるべきだ、という我々の信念に根差したものです。

——ストリートカルチャーを尊重する。社会と同期して常に同じ地平に立つ。そのためにオフィス内にもミクストユーズな状況を優先してつくる。そしてクリエイティブシンキングで、社会に対するあなたたちなりのメッセージ

▼2 ウォールナットエリア
ウォールナットは格式や伝統を重んじる金融系オフィスや弁護士事務所でよく使用される内装材。ウォールナットエリアとは、そうしたスタブリッシュな業種が多く集まる地区を指す。

▼3 オーガニゼーションマン
自立、独立した個人を指すインディペンデントの対義語。組織人の意。

を生産していく。W+Kの企業文化が少しだけ分かってきました。

ストリート主義

——あなたは今、パールに隣接するチャイナタウンの再生に個人的に力を入れてますね。あなたにとって理想的な街のイメージとは？

J　クリエイティブな人種が生活しながら働ける環境が前提となるでしょう。そのためには、ネイバーフッドレスト[▼4]ランやネイバーフッドなストアの存在とその質がとても重要になってくると言えます。そしてそれにはナショナルチェーンよりもローカル企業の方が相応しいのではないでしょうか。なぜならその方が真の社交空間が生まれやすいですから。ローカル企業の場合、彼らと我々との関係はBtoCというよりはむしろPtoP（パーソンtoパーソン）に近い。それが生活の質として還ってくるんです。

またクリエイティブなコアの存在も不可欠です。パールの場合、わたしたちW+K以外にも、PNCA、クラフト・ミュージアム、Ziba Design等、若い才能が集まる拠点が幾つも揃っています。中でも私は、PNCAの存在がパールの街のアイデンティティ形成、クオリティ維持にとって、極めて大きな役割を果たしていると思います。彼らはビジネスやマーケティングとは一線を画した立場で、純粋なクリエイティブシンカーを育てていますからね。

——荒れ果てたインダストリアルエリアに若いアーティストがやってきて、ゲリラ的にアートコミュニティを形成する。やがてそこに革新的な企業や大学がやってきて街の骨格を整えていく。世紀的都市開発の文脈では、それ以降は不動産デベロッパーたちの主戦場と化し、マネー原理主義の末にどこにでもあるスノッブな街へと成り下がってし

▼4 ネイバーフッドレストラン
住宅街にある日常的にカジュアルな使い方のできる、我が街の飲食店。

まう。この流れに対するアンチテーゼが描けるかどうか、つまりパールが将来にわたってインディペンデントでリベラルな今の雰囲気を保ち続けるためには、御社のようなカッティングエッジなシンボルの存在がとても重要なんだと思います。

J 誤解してはならないのは、街に立派なミュージアムを誘致することが、都市をクリエイティブにする要因とはならないということです。大事なのは常にストリートに芽生えるユーススピリットの方だと言うことを、肝に命じる必要があります。彼らがその気になって動き始めなければ、社会的な新しい

ムーブメントは決して起こらないので す。それがクリエイティブエナジーの 本質です。企業の論理や行政施策、ま してや大規模開発なんかではクリエイ ティブなコミュニティなどは発生し得 ないのです。逆から言えば、そうした ストリートレベルにおけるユーススピ リットの存在に注意を払い、見つけ、見 守る寛容性とリスクテイクする包容力 をもったビジョナリーの存在さえあれ ば、街はそう簡単にマネーマーケット に蹂躙・消費されるものではないと思 います。そして、我々は常にそうあり たいと願っています。

——恐れ入りました。

オフィス内コモンエリア。時としてここは、音楽イベントや自転車デザインの展示会などのイベント会場となる。もちろん街に対して開かれた無料のオープンイベントが原則だ。社会とシームレスにつながっていること。W+Kの信条のひとつだ

「若い才気溢れる無名のアーティストにチャンスを与えること。そしてリスクを取ること。ニューヨークやロンドンの売れっ子クリエイターではなく地元の才能を活用すること」。それがW+Kの精神だとジョン・ジェイ氏は言う。この創造的な空気に満ちた同社の本社ビルもまた、地元ポートランドの建築家の手によるもの。建築家はこのデビュー作の成果もあって、今や世界中で引っ張り凧だという

「オフィスは現実社会のアナロジーであるべき」ジョン・ジェイ

パールディストリクトのもつアーバンスピリットを一言で表せば「ク
リエイティビティとオープンマインド」。街に息づくこうした精神
を形成している一端が、PNCA（アートカレッジ）やワイデン＋ケネ
ディ、アートギャラリーの存在だとジョン・ジェイ氏は言う。氏
の現在の関心は、パールディストリクトに隣接するチャイナタウ
ンにアジアの若い創造的な才能を結集させること。既に自らレ
ストランとスタジオを構え、着々とクリエイティブな震源地づくり
の構想は動いている。これが上手く行けば世界中のチャイナタ
ウンが生まれ変わるかもしれない

世界中の応募者の中から選別された12名の先鋭たちによる1年間のスクーリングプログラム「WK12」のコーナー。選考にあたってはクリエイティブ産業の従事経験やスキルよりも「インタレスティングピープル」であることが優先される。クリエイターとはもはや優秀なデザイナーのことではなく、創造的なアイディアで社会的な課題を解決したり、人と人、人と企業との間に新たな関係を構築できるクリエイティブなシンカーを指していることが、ここに居るとよく分かる

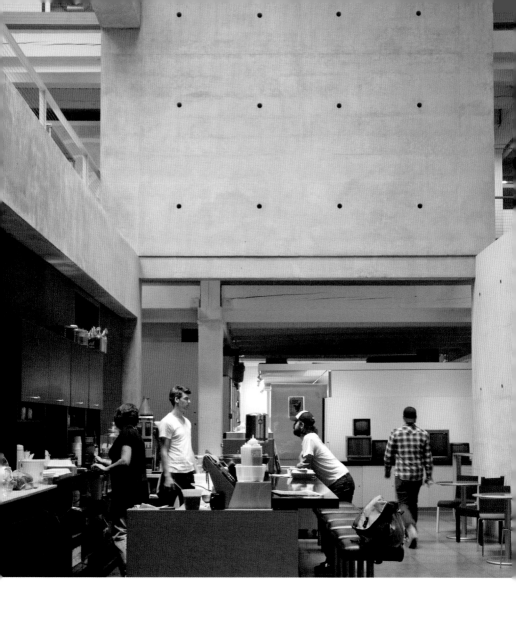

コージーなネイバーフッドレストラン？
然(さ)に非(あら)ず。ここは同社のオフィス内にあるカフェ

オフィスは大部屋と部署ごとに隔絶された
小部屋の集積というより、チームごとのセミ
オープンな空間が余裕あるパブリック空間
の中に点在するといった風。自立しながら
連携する館まるごと創発エンジンの如く。例
えるなら、テナント間の間仕切り壁を創造
的に解体した伊勢丹新宿本店メンズ館や
バーニーズ・ニューヨークの空気感

オフィスエントランスに掲げられたスタッフ
ポートレートは全世界共通、Ｗ＋Ｋお馴染
みの光景だ。個人と組織の絶妙なバランス。
インディーズ精神の証

アートと街の良好な関係

ファーストサーズデイ

First Thursday

アートコンシャスでなおかつハプニング好きなパールディストリクト住人たちの格好の社交機会がファーストサーズデイだ。
毎月第1木曜日、パールディストリクトは街を挙げてブロックパーティの舞台と化す。

同時一斉のオープンギャラリー

パールディストリクトには約25軒のギャラリーがあるが、どうせならギャラリーの新作発表日を統一して、皆で一斉にオープンギャラリーを開催した方が、その効果は相乗するのでは。こうして始まったのがファーストサーズデイだ。事務局を務めるのは、14軒のギャラリーで組織するPADA（ポートランド・アート・ディーラーズ・アソシエーション）。とは言うものの、個性や独自性が身の上のアートギャラリスト達のこと。参加ルールや運営規則は各々の自主性に任されており、その縛りは極めて緩いものらしい。例えば開催時刻は原則夕方6時から9時と決まってい

るが、実際のお開きはギャラリーによってマチマチで、ワインを振る舞うギャラリー、バンド演奏のあるギャラリーなどでは、その賑わいは深夜にまで及ぶという。

このファーストサーズデイのギャラリーウォークと同時刻に、路上では毎回「ストリート・ギャラリー・エキシビション」が開催されている。こちらは未だギャラリーで作品を発表できない発展途上のアーティストを対象に、車の交通を遮断した3ブロックに渡るストリートを舞台に90のブースを設営、事前登録を済ませたアーティストに作品の発表・販売の場を提供するというものだ。こちらは、厳冬期を除く毎年4月から11月の毎月第1木曜日の夕方5時から夜10時まで開催されている。

▼1 オープンギャラリー
ギャラリーが新作発表時に開催するお披露目展示パーティ。

▼2 PADA（ポートランド・アート・ディーラーズ・アソシエーション）
ファーストサーズデイ・イベントの事務局。

Q&A
Q1：ファーストサーズデイ「ストリートギャラリー」への参加申込方法は？
A：それはウチじゃない。アーバンアートネットワークを訪ねてみてほしい（107頁参照）。

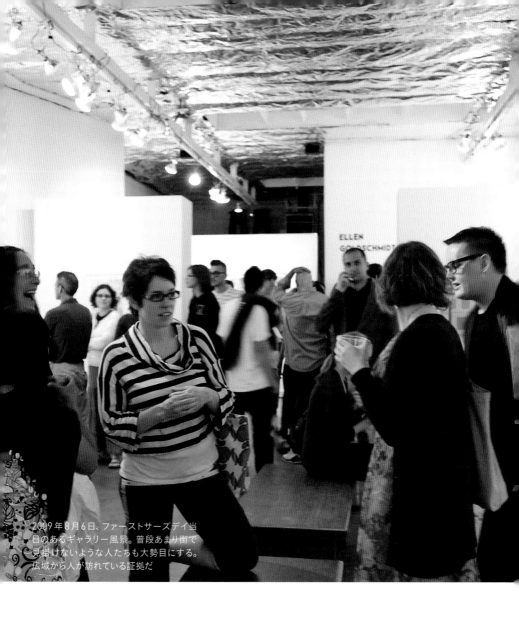

2009年8月6日、ファーストサーズデイ当日のあるギャラリー風景。普段あまり街で見掛けないような人たちも大勢目にする。広域から人が訪れている証拠だ

Q2：アートをもっと知りたいんだけど、どうすればいい？

A：評判の良いギャラリーに行くことをお薦めする。そしてスタッフに直接尋ねてみるのが一番。ギャラリーは展示している作品に関するエンスー（達人）といえる。だから彼らから知識を分けてもらうのが最適だ。ギャラリーやディーラーとの間で関係を築くことは、どちらにとっても大事なことだ。それからアートにはオープンマインドで接すること。そうしたら審美眼が更に養われること請け合いだ。

月に一度のアーバンメッカ

既にポートランドの名物イベントとして定着したこのファーストサーズデイは、パール中のブティックやカフェ、レストランはもちろんのこと、学校や一部の企業までが祭りモード全開でスペシャルメニューやオープンハウスパーティを開催し、夜中まで街中に喧噪が鳴り止まない。こうした街を挙げてのオープン・ギャラリー・イベントは、本来ギャラリーに付きもののスノッブさを軽減し、多くの人々にギャラリーの敷居を跨がせる格好の機会となっている。その気にさえなれば、幾らでもギャラリーオーナーやアーティスト本人と直に触れ合えるのだ。もちろん祭りにトラブルは付きもので、弊害も指摘されてはいるものの、このアートをテーマとしたブロックパーティは月に一度のアーバンメッカ（都市の聖地）として定着し、パールを象徴するアートイベントと成り得ている。PADAによると、当日の来街者は1.5万人から2万人と発表されている。

BLACKFISH GALLERY。設立は1979年、アートギャラリーの老舗だ

Q3：ファーストサーズデイは有料なの？
A：アソシエーションに加盟のギャラリーはどこも無料。市民に広く開放している。

Q4：アートギャラリーで扱う作品のジャンルは？
A：ほとんどのギャラリーで広範囲なジャンルを扱ってる。絵画、彫刻、写真、ガラス工芸、映像といった風にね。

ストリート・ギャラリー・エキシビション

ファーストサーズデイ時に同時開催されるストリート・ギャラリー・エキシビション。その運営組織であるUAN（アーバン・アート・ネットワーク）プレジデントのジェニファー・カプネックさんに街とアートイベントの関係について聞いた。

Urban Art Network
President

Jennifer Kapnek

若手アーティストの発表機会

ファーストサーズデイは、そもそもギャラリーの新作発表のお披露目パーティが発端よ。その内、ギャラリーがまだ付かないアーティストたちが自分の作品を路上で展示し始めたの。彼らは深夜までワイワイやるもんだから、周辺の住民は顔をしかめたわ。中には酔った上でのトラブルもあったそうよ。想像できるでしょ？

そこで、有志で「ファーストサーズデイ・ストリート・アート・ギャラリー」という団体を立ち上げて、アーティストと地域間の調整役を買って出ることにしたの。それが今から約10年位前のことよ。やがて活動内容を広げたのを機に名称を今の「UAN（アーバン・アート・ネットワーク）」に変更したってわけ。

わたしたちの使命は「インディペンデントで活動しているアーティスト支援」よ。ストリート・ギャラリー・エキシビションが開催されない冬期の間、彼らの作品展示場所を確保するための交渉を行ったり、問題が起こるのを回避する目的でコミュニティや企業を交えてオープンミーティングを主催して、解決策を探ったりしているわ。アーティストにはUANへ

の登録を呼びかけていて、今で350人位よ。でも団体行動を嫌うアーティストも当然ながらいるわね。ストリート・ギャラリー・エキシビションで与えられるブースを嫌がって、外でもっと自由に発表したい人とか、私たちの存在をうっとうしく思ってる人とか、もちろんいるわ。そもそもアーティストは束縛されるのが大嫌いだから、それも当然ね。片や、月1回のエキシビションは騒がしすぎて、街自体にお客が寄り付かないと、イベントに批判的なレストランオーナーもいるわ。でも公明正大にストリートギャラリーが開催できるようになったのもまた事実よ。一つひとつ絡まった糸をほぐしてって感じかしら。UANのボードメンバーは私を入れて3人。もちろん皆アーティストよ。私はペインター。ニューヨークからここにやってきたわ。なぜボードメンバーになったのかって？ この活動は私自身の作品発表の場と機会を確保するための命綱でもあるからよ。ファーストサーズデイにはもの凄い数のオーディエンスがやって来るから、アートマーケットとして魅力的なのは確かよ。

「緊張していること、興奮していること、ドラマチックであるということが、都市の最も優れた資産の一つである」ジェイン・ジェイコブス

パールディストリクトには元倉庫や工場を
利用したレストランが少なくないが、それら
建物に付きものの荷捌き用ローディングデッ
キ。ブロックパーティの際はここが絶好の
特等席となる

ファーストサーズデイの当日、溢れんばかり
の賑わいを見せる路面の開放的なラウンジ。
ワイングラスを受け取る際に尋ねたら、なん
とそこはデベロッパーのオフィスだった

クリエイティブシンカーの生まれるところ

パシフィック・ノースウエスト・カレッジ・オブ・アート

PNCA

ある時はパシフィック・ノースウエストにおける文化的ランドスケープ、ある時はポートランドのクリエイティブコミュニティのインキュベーター、またある時は全米で最も急成長している独立系アートカレッジ。そんな代名詞で呼ばれるパールの象徴的拠点の一つがPNCAだ。

自身卒業生でオレゴニアン5代目でもある、同校の入学カウンセラー パトリック・メルロイ氏に校内を案内してもらった。

クリエイティブコミュニティの真ん中にあるアートカレッジ

——我々を入学したての新入生と見立て、大学のオリエンテーションをお願いします。

パトリック（P）　創立は1909年（当時の名前はミュージアム・アート・スクール）、パールディストリクトには1998年に市内の別の場所から移ってきました。2009年現在の学生数は514名、大学院生45名。パールの中に3つの校舎をもち、4つ目の校舎が2014年に開校する予定です。学部はコミュニ

ケーションデザイン、イラストレーション、インターメディア、ファインアート、絵画、写真、印刷、彫刻の8部門から成り、卒業生はBFA（芸術学士）が授与されます。またPNCAはビジュアルスタディとクラフト＆デザインの二分野においてMFA（芸術修士）を取得できるパシフィックノースウエスト地域で唯一のアートカレッジでもあります。掲げている使命は、これはあくまで僕なりの表現なんだけど、社会的な問題や課題に対して創造的に解決できる人材を育成する、というもの。過去3年間で入学希望者数は43％アップを達成、5年前と比較して約2.5倍伸びて

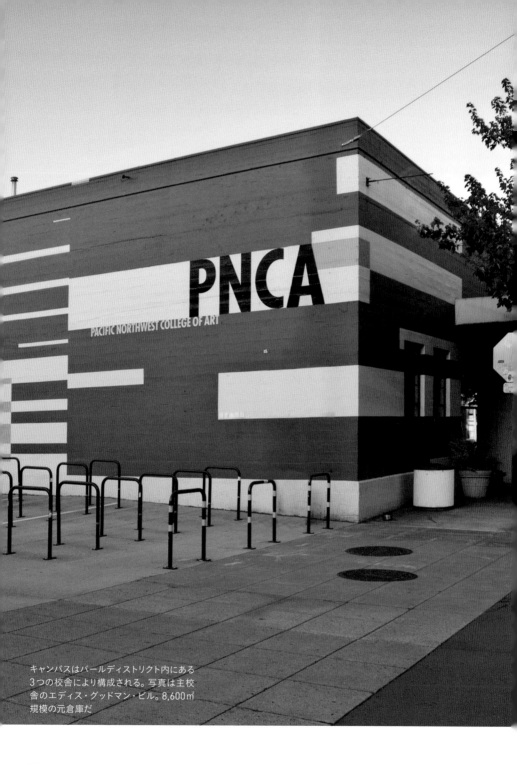

キャンパスはパールディストリクト内にある
3つの校舎により構成される。写真は主校
舎のエディス・グッドマン・ビル。8,600㎡
規模の元倉庫だ

います。特に今年（二〇〇九年）は、開校100周年に当たり様々な催しを展開中ですが、今後も過去100年以上にアート＆デザインに関する地域一番校としての役割とイノベーションのための触媒機能を強め、市民生活や地域経済の発展、カルチュラルリーダーの輩出に貢献していくつもりです。

——ありがとう。アートカレッジと街との関係性について聞きたいんだけど、パールに対してPNCAはどんな影響を及ぼしていると思う？

P　僕の祖父は僕がパールディストリクトにある大学に行ってるとか、今はパールに200万ドル以上のコンドミニアムが建ってると話しても怪訝な顔をするだけ。あそこはインダストリアルエリアで治安も悪いといってね。彼は今でもパールの変化を信じてはいないんだ。僕が日々感じるパールは、ウォーカブルで高密度で、おいしいパ

ン屋やコーヒーショップがあって、もちろん犯罪も少ないからとても気に入ってる。古くは70年代後半にここの倉庫街を目指して多くのアーティストがパールに移り住んできたという経緯があるんだけど、クリエイティブコミュニティの真っ直中にアートカレッジがあるってのは、とても意味があることだと思うよ。今は若い成長途上のアーティストはもう家賃が高くてここには中々住めないけどね。

——具体的にアートカレッジは街に対してどんな作用を及ぼしてると思う？

P　クリエイティブなコミュニティの核となって、ルーティーンな日常生活やドライな毎日に対して特別な刺激（エキストラスパイス）を与えていると思う。具体的には新しいこと、未知との出会い、刺激、情緒的な潤い、いつもの日常を越えた付加価値、ちょっと余分なもの、変化、生活への味付け、非日常

**PNCAの
基本的価値と教育目標**

●PNCAは、生徒一人一人が美術及びデザイン分野におけるクリエイティブな業績を一生涯を通して維持する力を身につけることを意図している。世界が作り出す様々な状況や出来事を解釈し、そのような世界やそれぞれの文化に、理解と情熱、そして誠実さを持って取り組む力を強化する。

●美術やデザインとは、人類や文化的な努力を理解する上での手がかりを探究する重要な分野であるとPNCAは考える。この分野を学ぶことにより、詳細な情報に基づく倫理的判断を下す力を身につけ、多様性に対する繊細な理解を深め、変わり続ける世界に対応するための自信を育てることができる。

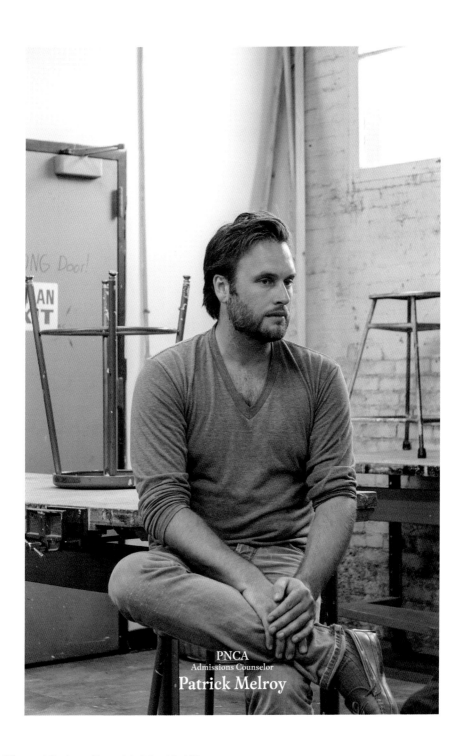

PNCA
Admissions Counselor
Patrick Melroy

性……、それがエキストラスパイスの意味だよ。

――街のアイデンティティ形成やブランディングにとって、アートカレッジの存在はどれだけ寄与してると思う？

P　そんな考え方のアプローチはした事がないな。そもそもアイデンティティのないところにイメージを後付けしようとしても無意味だと思う。街にどういうお洋服を着せてコミュニケーションを図るかではなく、どうやってオリジナリティのあるコミュニティを創り出すかの方が重要じゃないかな。パールの場合はギャラリー、ミュージアム、クリエイティブな人種が揃っていて、クリエイティブなコミュニティがあるけど、アートカレッジなしにそれは生まれなかったと思う。アートカレッジがあってこそアーティストやクリエイティブシンカーが生まれ、ギャラリーが集まり、ミュージアムが移って来て、というスパイラルが生まれるんじゃないかな。それらをつなげてダイナミズムを生むエンジンがアートカレッジの存在ではないかと思う。

――若い才気に溢れたアーティストにとって、もうパールには不法占拠できるようなロフトもないし、街は洗練された人たちに取って代わってしまったと思うけど、クリエイティブなスパイラルはこれからも廻ると思う？

P　その感は確かに否めないね。だけど今でもエマージング（成長途上）なアーティストたちに作品展示の場所を提供するイベントをこの街は続けている。懐の深い街だと思うね。なぜならここに住んでる人たちは皆一様にインディペンデントでクリエイティブでカッティングエッジな雰囲気を好んでここに移り住んでるわけだから、その流れはそう簡単には止められないと思う。ニューヨークのSOHOのようにはならない

♥ 生徒のそのような成長を助けるため、PNCAでは工房作業や研究に対するコミットメントを促進する、優れたアーチストやデザイナー、学者を数多く登用している。教師陣は協調的な学習をサポートし、コミュニティとの緊密な関わりを促進し、異文化間の交流を促し、倫理的な行動を推奨し、また効果的な文章作成やスピーチ、討論を尊重している。

♥ 創造的実践（Creative Practice）、総合的な知識と批判的思考（Integrated Knowledge and Critical Thinking）、社会的倫理的責任（Social and Ethical responsibility）、そして効果的なコミュニケーション（Effective Communication）というPNCAの4つの教育目標は、これらの価値と能力を生徒に推進、育成、定着させ、創造と達成の人生を実現す

と思うよ。

――いわゆるロフト文化華やかかりし頃の野性的なアートコミュニティの時代がパール1.0だったとしたら、彼らが去った後のパール2.0はどうイメージできる?

P　アディダスやナイキやグーグルは、いずれも成功を収めた企業ではあるけれど、それで成熟しきっちゃって自らの進化を止めるって事態には全然陥ってないよね。今でも新しい才能ある若者たちを次々と受け入れて参加させている。同様にパールディストリクトにも従来の音楽、芸術、パフォーミングアートといったいわゆるアート分野の枠を越えて、知的層やナレッジワーカーが集まりつつある。だからPNCAもクリエイティブシンカーを養成し、社会的課題に対して創造的解決を図れる人材を育てようとしているんだ。絵の具だらけのカーペンターパンツを穿い

た人たちばかりを育てているんじゃない。つまりアート&デザインの根本にあるクリエイティブ能力を発揮する領域の拡張が、これからの進化の条件といえるね。

マーケティングより
クリエイティビティの時代

　ポートランドには昔からアンチ市場原理主義者たちが集まってくるという特徴がある。ここにはイノベーティブな考え方を歓迎すると共に、大企業のシステマチックな標準型サービスよりインディペンデントでの身の丈的なやりとりの方を好むという気質が根強く残っている。20世紀の消費社会においては、それはいささか時代の流れに逆行する、イケてなくてへそ曲がりの印象を放っていたかもしれない。しかし環境共生的な生き方が求められる今日においては、こうした自由で柔軟な発想と等身大の生活態度の方が進歩的でスマートであるような気がしてくる。

出典：June Board Report
Appendix I

る力を身につけさせる。

1階レセプションカウンター

経済の成長・拡大時においては、モノの大量生産・計画的陳腐化、あるいは消費や取得に対する歓びが主流の、いわばマーケティングが社会をリードする時代だったのに対し、経済の縮小・質の充実が求められる現代においては、クリエイティビティによる創造的試行

錯誤や革新的な価値の創造行為自体を楽しみ、謳歌するマインドの方が主流となるのかもしれない。

ここでクリエイティビティと環境共生と都市文明の3要素が集約されたわけだ。

メイン校舎内のザ・コモンズ（公共空間）。エントランスをくぐってまず最初に到達する大空間だ。ロフトのような白い壁と高い吹抜け天井の開放的な空間は、授業からコーヒーブレーク、ランチからパフォーマンス、デザイン展覧会から詩の朗読会まで、多様に使われる学生たちの拠り所だ

photo：Chloe Dietz

校舎内のライブラリー。ここには1958年以
降の総ての卒業論文がストックされている。
写真では見えないが手動の旧式タイプライ
ターが数台置かれているのを発見。尋ねて
みると、「停電でパソコンが使えなくなった
時のためさ」との弁。果たして冗談だったの
か、真意は今でも分からない

モダンボヘミアンの眠るところ

エースホテル
ACE HOTEL

カッティングエッジだけれど適度に脱力していて、クリエイティブだけれどフレンドリーで、クールだけれどファンキーなポートランドのユニークさを120%反映した場所がある。エースホテルだ。

リーバイス的普遍性

シアトルに本拠地を置くエースホテル1号店が、次に選んだ場所がこのポートランドだ。現在は他にパームスプリングス、ニューヨークにも出店している。シアトルにエースホテルが誕生したのは1999年。それまでのデザイナーズホテルとは一味も二味も異なる、その力の抜かれた独特のブティック感覚は、誕生するや否や瞬く間に一部の先端的メディアや新し物好きたちを魅了し、次世代のデザイナーズホテルのモデルとも呼ばれ話題をさらった。ジーンズに例えるなら、従来のデザイナーズホテルがD&Gの5万円のプレミアムジーンズなのに対して、エースホテルはさしずめ容易に手に入る古着のリーバイス501という感じ。正にポートランドにうってつけのアコモデーション(宿泊施設)だ。進出の動機をエースホテルの共同所有者、アレックス・カルダーウッド氏は次のように語る。

「パールは、何もなかったインダストリアルエリアを人々が計画的につくり上げていった場所。ここには文化的で自立した魅力的なコミュニティも育っている。ポートランドの中にあってもっても興味深いエリアだったね」

これまでの都市開発の多くは、古い建物を壊し道路まで付け替えた上でビルを建て、街をツルツルの新品に一変させるスクラップ&ビルドが主流だっ

▼1 ボヘミアン
定職を持たない芸術家や、社会の規範に捕われず、自由奔放な生活を志向している人。ボヘミアンが多く住むコミュニティをボヘミアと言い、古くはパリのモンパルナスやサンフランシスコのヘイトアシュベリーが該当する。

▼2 リーバイス501
米国リーバイ・ストラウス社が開発したジーンズ名。誕生から140年の歴史をもつジーンズの原型であり、現代においてもジーンズの代名詞にしてジーンズの最終到達点とも呼ばれることも。永遠のスタイル。

建物はかつてクライドという名のホテルとして使われていたもので、竣工は1912年。1階のレストラン「クライドコモン」はそこからきている。客室数は79室

た。一方パールの場合は古い建物と新築のビルが共存し、文化的奥行きを備えていた点が彼らのフィーリングと合致したようだ。

「古い建物もこれ見よがしに古さを誇るんじゃなくて、今日的センスでモダンに使えるように計算して手が加えられている。その結果、空間やそこでの生活自体に豊かさがもたらされるんだと思う。それがパール的生き方なんじゃないかな」

ここポートランドのエースホテルもまた、約90年前に建てられた古いホテルを再利用したものだ。

材料から才能まで、地産地消

それにしても2006年の開業から3年（取材時）で、早くもポートランドの顔の一つとなったエースホテルの実力には興味が尽きない。

「一言でいえば、オネスティ（誠実さ）だと思う。他のホテルなら客室のベッド

リネン一つ決めるにも本部にお伺いを立てて、その指示に従う必要がある。そして恐らく、本部が開発途上国に一括発注した製品が送られてくるのがオチして恐らく、本部が開発途上国に一括発注した製品が送られてくるのがオチさ。でも僕らの場合はローカルの材料を使い、ローカルのアーティストに部屋のデコレーションを頼むという風に、ポートランドの優れたところをそのまま誠実に活用させてもらった」

その無理をしない等身大で勝負するという誠実さが、コミュニティに受け入れられ評価につながった要因だという。確かにポートランドでは、食物の地産地消運動と同様に、物事全てに対して地元の才能、地元の材料を優先するという意識が強い。地理的要素も一因だとは思うけれど、本当のところは分からない。でも環境意識に対するエシカルな姿勢のみが、そうした態度を取らせているのではないことは確かだ。ひょっとしたら、この感覚こそが低炭素時代における社会参加のマナーなのかもしれない。Think global, eat local

▼3 インダストリアル
エリア
産業地帯の意。パール
ディストリクトは古く
は鉄道操車場、並びに
全米から太平洋航路に
出るための貨物が集ま
る倉庫街であった。

124

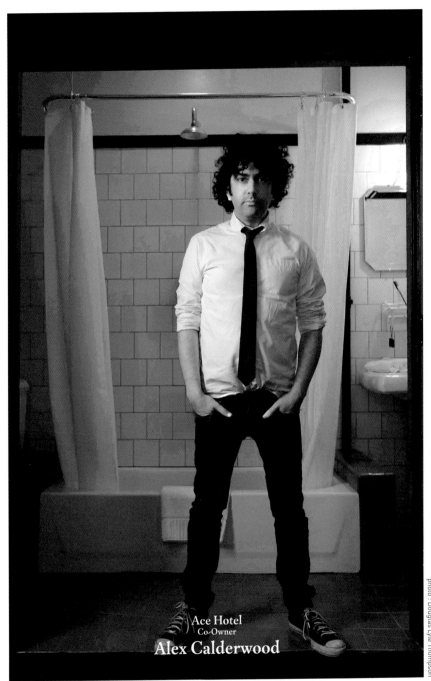

Ace Hotel
Co-Owner
Alex Calderwood

photo : Douglas Lyle Thompson

と同じように。

街のアンバサダー

エースホテルの中でも、その寛容性とリベラルさで特にエースホテルらしさを象徴している場所がある。1階のロビーラウンジだ。17インチのMacBook Proを広げている者から、ピチッとしたバイシクルスーツで全身を被い足下に膨れ上がったメッセンジャーバッグをはべらせている者、ベビーを連れた肥満体型の典型的アメリカ肝っ玉かあさんに至るまで、あらゆるタイプの人々が長いカウチとここの空気をシェアしている。

「我々は地元に根差してビジネスをしている以上、地元の人々を受け入れるのは当然のこと。インターネット、雑誌、新聞はもちろん心身ともにくつろげるカウチととびきり美味しいコーヒーショップを用意して、使いたい時はいつでも使って欲しいと思っている。ホテルはその街を反映する空間であるべき。だってその方が宿泊者だって旅の気分を実感できるでしょ」

もちろん大方のホテルが同様に「ロビーラウンジは街のリビングです」とうたっている。でも仮にオフィスや家の近くにシティホテルがあったとしても、日常的にそこを利用するかと言えば果たしてどうだろう。車優先のエントランスや人種の異なるホテルマンの存在、感覚的な共感とは程遠い存在だ。でも、ここエースホテルには紛れもなくスターバックスのように四六時中人々がたむろして止まないのである。我が国の「喫茶室ルノアール」のように。

近所に居を構えるガス・ヴァン・サント監督の映画「ドラッグストアカウボーイ」(1989)では、ウィリアム・S・バロウズが棲む「セント・フランシスホテル」として登場している

▼4 喫茶室ルノアール
都内を中心に1970年代から続く喫茶店(同社は「喫茶室」を標榜)。座高の低いラウンジーな椅子とゆとりのある客席間隔、テーブルサービス(非セルフサービス形態)と熱いおしぼりサービス等々。大人同士のタフな商談から一人ドストエフスキーと格闘する読書まで、あらゆる都市生活者を受け入れる元祖東京のサードプレイス。

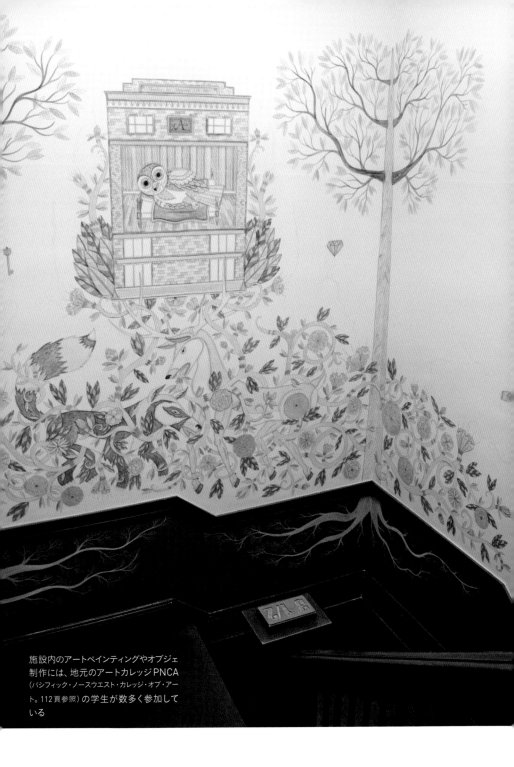

施設内のアートペインティングやオブジェ
制作には、地元のアートカレッジPNCA
（パシフィック・ノースウエスト・カレッジ・オブ・アー
ト。112頁参照）の学生が数多く参加して
いる

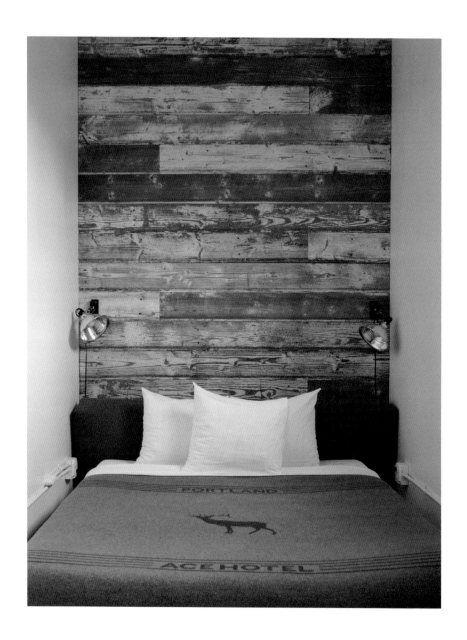

ベッドリネンはここオレゴンで140年以上の
歴史をもつウールメーカー、ペンドルトン社
製。ローカルファースト（地元優先）の精神に
貫かれている

メザニンフロア（中2階）にあるライブラリー。
世に数多あるデザイナーズホテルとの最大
の違いは、ホテルが古着感覚に満ちている
ということ。そこには歴史や古さというより、
ある種の文化的深みが漂っている

メザニンフロアから見た1階ロビーラウンジ。
朝の時間帯はコーヒーカップを手にした老
若男女で溢れ返る

一部の客室にはターンテーブルが設置され
ている。宿泊客はフロントで気に入ったLP
盤を選んで持ち込む仕組みだ。その手作業
とアナログ感覚こそがエースホテルらしさで
あり、ここがインダストリアルシックやワーム
ミニマル（warm minimal）、モダンボヘミアン
と呼ばれる所以

ACE HOTEL

10TH TO 11TH AVENUE

AT STARK STREET

PORTLAND 5, OREGON

TEL: 50 32 28 22 77

FAX: 50 32 28 22 97

A FRIENDLY HOTEL

CONTINUALLY NEW

「ハートのエース」、いやエースホテルのエー
ス。右写真は「持続的におニューでフレンド
リーなホテル」と書かれたシャワーカーテン

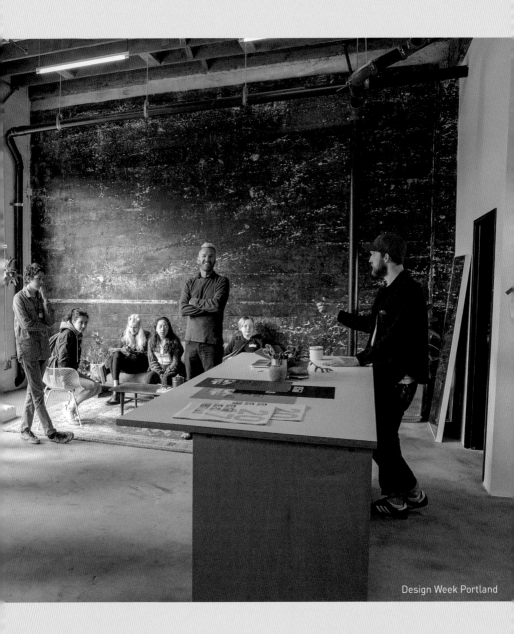

Design Week Portland

Sense of Creativity

" アーティストだけでなくポートランドに来た
人たちはどんな人でも、競争（コンペティション）
し合うのではなくて協創（コラボレーション）し合
う方が先に立つ。こうした傾向はグローバリ
ゼーションや資本主義への反発からきている "
——————— ペインター

" 人類が直立歩行をするようになって以来、衣
服を身につけることは当たり前。だから、自
分の着る服くらい自分でデザインしたいと思
う。失敗するかもしれないが、やってみたい
と思う。そうした思いが人をクリエイティブ
にするし、自分はそれを楽しんでいる。建物
に関しても同じことだ。非常に大胆で明るい
デザインで、横を通る車が建物に見とれて事
故を起こしてしまえばいいとさえ思う。その
時に自分が最高に没頭できるものをつくる、
それだけだ。

　建築家として教育を受けているが、自分は
不動産デベロッパーであり、その唯一の理由
はデザインを自分で所有したいから。デザイ
ンの実験をしたいんだ。もし自分が組織事務
所に雇われたら、規律から外れることを恐れ
て安全に見えるデザインをしてしまうだろう。
なぜならそれはクライアントのお金で、自分
はそのお金で実験をしたいとは思わないから。
その点、自分は不動産デベロッパーであるか
らプロジェクトは自分のものだし、開発資金
は自分が集めたお金であり、リスクは自分が
負う。だから何の躊躇もなく自分のプロジェ
クトはとことん実験的にしたいと考えている。
ハイリスクではあるが自分はリスクへの欲求
が高く、リスクの高低が判断の邪魔になるこ
とは一切ない。そしてそれは同時に自分に自
由を与えてくれる "
——————— デベロッパー

photo : Ian J. Whitmore

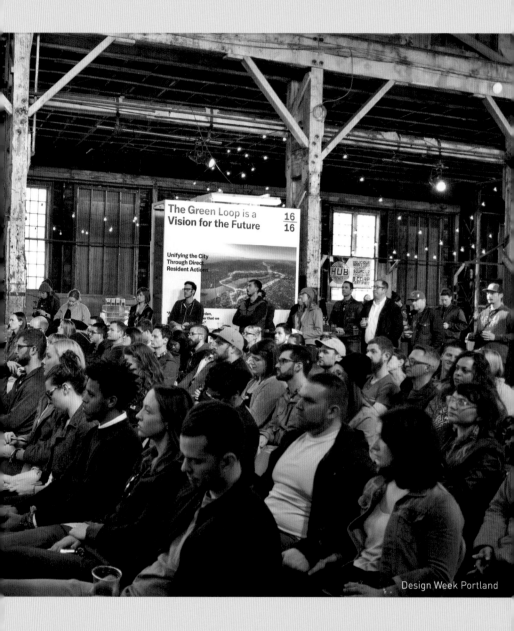

The Green Loop is a Vision for the Future

16/16

Unifying the City Through Direct Resident Actions

Design Week Portland

Sense of Business

66 私たちが扱う製品は、すべてリアルに機能するもので、リアルな必要性から生まれ、リアルなクラフツマン（である私たち）によってデザインされ、リアルな手作業で作られたものである。私たちは全ての製品を、それが生活において必要だからという理由で作っている。「これなら売れるだろう」という考えで作った製品は一つもない 99

──────── アパレルメイカー

66 長く残るものを少しだけ作ることがより価値があることだと考えている。我々は大規模なエージェンシーと比べるとクライアントの数は少ないが、彼らよりも長くクライアントとの関係を維持している。一つのことにかける時間も長く、本来もっと時間を費やすべきなのに時間がなくてできない仕事を受けるよりも、正しいことに時間を費やしていると考えている 99

──────── ブランドコンサルタント

66 自分の目標は利益を最大化することではなく、それなりのお金を得られればそれでいい。つまり、これで「十分」という考え方を大切にしている。相応ってやつだ。たとえば、食の例だが、フランス語には「満足した」という意味合いの考え方がある。物理的に腹が満たされるまで食べるのではなく、「心身の満足」を得られれば十分、という考え方だ。そうでなきゃ美しくないし、第一病気になっちまう 99

──────── デベロッパー

photo : Matt Gendron

ワーク・ライフ・バランスっていうのは古い
考え方だね。仕事を楽しまなきゃ人生をエン
ジョイできないじゃないか。それだと仮に失
敗したとしてもそれを自分の糧にできる。だっ
て旅行でもパーティでも、インスピレーショ
ンを感じたら直ぐにスケッチしたくなるし、
仲間に"うまい溶接方法が見つかったぜ"っ
て話したくなるのが自然だろう。

　僕らはよくライバル企業のファクトリーを
互いに訪ね合うよ。新しい機材が入ったらす
かさず試させてもらう。お互いそうしてる。
だって僕らはゼロサムでは物を考えないんだ。
NYやLAの大都市と違って、ここではTV
で紹介されてないブランドでも、製品や思想
が気に入ったら買ってもらえる。ここの人た
ちは見る目があって、サポートする感覚で物
を選んでくれるのさ
——————— プロダクトメイカー

会社の規模が大きくなるほど、自分たちの持っ
ているスピリッツやモットーを保つことが難
しくなる。従業員のために面白くないビジネ
スを取ってこなければならないからだ。それ
を考えると15人というのが組織の上限だと
思う
——————— クリエイティブエージェンシー

photo : DYSK

Design Week Portland

Sense of Creative Community

あるイベントで競合メーカーと話をしたとき、自分が悩んでいた発酵などのいくつかの問題を話したところ、「OK、これから言うことをメモしてくれ」って、自分に酒造りの秘密を話してくれた。またあるメーカーからは、「ここにある酒のどれでも作り方を教えてあげるよ」とも言われた。ここにコラボレーションが生まれる。ここでは他者とコラボレートし、コミュニケーションを取り、フレンドリーであるのは自然なことだ。そうしないとポートランドでは居心地が悪い。ただしそれは同時に、5人のシェフにまったく同じ材料を与えると、すべて異なる5種類の料理ができあがる、という考えが前提だ。だから秘密をライバルに打ち明けても全く同じクローンができるとは考えないんだ。そこには必ず別の人の手が入るからね。だからアート・オブ・ライフ。仕事の芸術化なんだ

—— ワインメイカー

photo : Daniel Cole

ポートランドでは、小規模なエージェンシーでも非常に力強い企業が多い。だからポートランド自体が一つの大きなエージェンシーだとも言える。その中に多くのブランドパートナーがいる。エンジニアが互いに協力し合って大手が行うようなプロジェクトをこなすこともできる。これは重要なパラダイムシフトだと思わないかい。それまでのコラボレーションは同じ企業内の異なる部署が集まる中で起こるものとされていた。つまりそれは企業対クライアントのものだ。でも今では複数の同業者、クライアント、市民が必要に応じてつながるネットワークができている

—— クリエイティブエージェンシー

クリエイティブな企業が好む空間とは、まず、彼らの創造性や革新性を邪魔しない空間を提供すること。建物の歴史的な文脈を大切にすること。さらに広いオープンスペースがあること。なぜならそこでは、アイディアや経験がテナントの間でシェアされるからだ。次に間仕切りのないオープンでとにかくフレキシブルなフロア空間。そして明るいこと。コワーキングスペース、イベントスペース、それにレストランやショップなど、皆でシェアできるアメニティスペースを備えていること。

　短期回収ではなく長期スパンに立った投資を心掛けること。地元の当事者たちが考えるビジョンに沿った開発を心掛けること。ネイバーフッドが発展するきっかけとなるプロジェクトを心掛けること"

—————— デベロッパー

ポートランドのコミュニティはとてもユニークだ。異花受粉が起こっている。クリエイティブな分野にいる人の多くは自分とは異なるクリエイティブな分野の人たちからインスピレーションを得ている。そもそもインスピレーションを自分や自分の分野に100％頼ってはいないんだ"

—————— レストランター

photo：DYSK　上段テキスト／現地取材・構成協力：小野アムスデン道子

of our practice's various facets
how ZGF introduces making
the design process Celebrating
value of learning and iteration,
event will express how we come
ther—at different scales and
diums—to inspire our teams and
nnovate. With ZGF's main lobby
stage, we will display a wide
ety of our work in order to spark
onversation about maker culture
is digital age.

Design Week Portland

Sense of Portlandia

> 最初にオレゴン州に来た人たちは西部開拓者たちのうち、金（ゴールド）に眼がくらんでカリフォルニアへ南下した人ではなく、ライフスタイルを求めてロッキー山脈を越えて西部にやってきた人たちだ。それは今でもある意味同じだと思う。ここは経済の街ではない。ここにはアメリカンドリームはない。人々は自分たちに合った生活や自分たちの仲間、そしてコミュニティを見つけることができるから住みたいと考えているのだと思う

—— レストランター

> かつてポートランドはクリエイティビティにあふれる街であったが、今はかつての姿ではなくなってしまった。自分がニューヨークから移ってきた当初のポートランドは遊び場のようだった。賃料は安く、生活するのに多くのお金を必要とせず、自分のしたいことができたから多くのアーティストたちが移り住んで来ていた。そしてそれが重厚な文化を生み、世界の注目を浴びた。今ではそれを目当てにあまりに多くの人が移り住んで来ていて、残念ながら、今ではアートを作る余地はあまり残っていない。今ではここでアーティストとして生き残るためにはプロフェッショナルなレベルにまで成長しなければならなくなってしまった。ニューヨークでもあるまいし

—— アパレルメイカー

photo : provided by Design Week Portland

66 ポートランド魂、それは自主独立、夢を信じ、
他人との協力や勤勉さを尊び、無から何かを
作り出す力を備えたオレゴン開拓者の精神に
根ざし、変わり者も受け入れる度量の深さ、
他人を尊重する正真正銘の親切心をもち、何
かをしたい人を支える文化と、それに惹かれ
て集まる何かをしたい人を受け入れる精神。
それがポートランド魂 99
───── クリエイティブエージェンシー

66 いまポートランドにおける一番の不安は、ポー
トランドで顕著なライフスタイルを送るクリ
エイターたちが追い出され、そうしたものを
ビジュアルで求めて来る人たちに取って代わ
られること。ポートランドらしさが一つの基
準で統一されてモノカルチャー化してしまっ
たら、途端におもしろい街ではなくなってし
まうだろう。既にその気配は感じている 99
───── ペインター

photo：DYSK　上段テキスト／現地取材・構成協力：東リカ

Design Week Portland

3章
Chapter 3_ Artisan Economy

アルチザンエコノミー
新しい資本主義のかたち

消費社会を超えて

集約から離散へ

　COVID-19がもたらしたソーシャルディスタンシングや都市封鎖の遺産として、アーバニズムに最も大きな影響をもたらしたのがリモートワークという新しい働き方だろう。それまで、誰もが思考停止的に無批判的に毎日会社に通勤していたのに対し、自宅あるいは自宅周辺の喫茶店やコ・ワーキング・スペースで代替できることを知ってしまった。COVID-19以降、会社に「集約」という常識が、一度ご破算で願いましてはとリセットされたのだ。では、ここから以降、せっかくのリセットの機会を生かして、私たちはどのような都市を心がけるべきなのか。あるいは、どのように働き・暮らしていくべきなのか。

　企業活動において、「集約」効果がさほど効いていなかったことは、日本の

労働生産性が、この十数年間、OECD加盟30余か国中20番台をさまよい続けていることからも明らかだ。日本がこのまま人口を減らしながら、経済を成長させ雇用を創出し、あるいは、脱炭素社会を実現し、国を子どもたちの子どもたちへとつなげていくためには、技術革新により全要素生産性を上げていく必要がある。

　1950年代半ばから1970年代前半にかけての日本の驚異的な高度経済成長を背景に、日本では日々の労働へのご褒美や次の労働に向けての英気を養う必要から、余暇活動、とりわけ「消費」というレジャーが奨励された。ある意味それは経済のラピッドグロースを担う馬車馬たる労働者の鼻先にぶら下げられた人参でもあった。三種の神器（電気洗濯機、電気冷蔵庫、白黒テレビ）、3C（カー、クーラー、カラーテレビ）、外食、観光、ハワイ旅行、ブランド品と、その推移は枚挙に暇がない。消

費と労働はコインの裏表として、ある
いは、消費は労働意欲を向上させるレ
バレッジ効果としてうまく機能してい
たのだ。で、現在はどうか。この経済
成長無き30年間、まだ我々は消費とい
う習慣を過去の惰性のまま引きずり継
続してはいないだろうか。もちろん、日
本のGDPの半分は個人消費が占めて
いる訳で、消費を全否定するつもりは
ない。しかし、労働による経済成長と
いうコインの表が不在の状態で、裏ば
かりは従前のまま、というのもおかし
い。見方を変えれば、より消費に勢い
をもたらす意味でも、コインの表に注
視し意識的となり、その活動行為と成
果を活発化させる必要がある。

高度経済成長時代の経済の主役は製
造業である。製造業は言うまでもなく、
工場を設置可能とする広大な土地と莫
大な量の水や電力エネルギーが原資で
あり、よって郊外がその舞台となった。
翻って現在の先進国においては、企業

の時価総額ランキングを見るまでもな
く知識集約型産業が経済の主役だ。原
資はまぎれもなく人材であり、彼・彼
女らが好む都市アメニティがあり、よっ
て都市がその舞台となる。成果物は技
術革新をベースとした新しい製品や
サービスだ。このことから、コインの
表は、かつての「労働」による経済成長
から今や「創造」による経済成長に変容
したと言えよう。端的に言おう。日本
が、いや、わが子が、その子どもたち
の子どもたちがいつまでも豊かに暮ら
していけるために、あるいは、我々が
幸福に過ごしていけるために、創造中
心の価値観に支えられた創造中心の社
会こそを心がける必要がある、と考え
る。

幸福と創造、創造の末の幸福

近年、ポジティブ心理学の研究が急
速に進んでいる。要は、人が感じる「幸
福（ハピネス／ウェルビーイング）」を定量

的に科学する研究だ。これによると、人が幸福と感じるのは、「自分から積極的に行動を起こすこと」、その結果の成功の有無ではなく、行動を起こすこと自体が幸福感を得ることにつながるのだという（『The How of Happiness』ソニア・リュボミルスキ UCR教授）。また、慶應義塾大学ウェルビーイングリサーチセンター長 前野隆司氏は、ウェルビーイングとは、自己実現と成長、つながりと感謝、前向きと楽観、独立とマイペースと記している。つまり、人は人と出会い、交流の中で啓発することで幸福や喜びや生きがいを感じるのだ。新たな英知と出会い共進化することで幸福や喜びや生きがいを感じるのだ。

さて、そろそろ話はポートランドに。クリエイティビティとは人間誰しもが備えている基本的資産である。ポートランドがユニークな点は、高いクリエイティビティを持つ天才が多く住むということではもちろんなく、クリエイティビティを生活を含めたさまざま

な場面で、さまざまな生かし方で発揮している人が多いという点にある。だから皆、生き生きと暮らしている。そうした環境下では、自分もやってみようかとか、もう1つ上を試そうかという気分が醸成されていく。街にはそうした個々のステップアップを発表するための場と機会が用意されている。例えば自家用車でファーマーズマーケットに材料を持ち込み、料理を作って販売し、上手くいったらフードカートを購入してフードポッド（市公認のフードカート集積場）に出店し、さらに成功したら路面店を開業するといった風に。つまり上に登る階段の段差が他の都市よりも小さくて登りやすい。だから挑戦しやすい。それが市民レベルでのクリエイティビティの発揮につながり、スモールビジネスが多産される。ポートランドが創造的都市といわれる所以だ。筆者はこうした草の根型創造都市、あるいはポスト消費文明都市の有り様を、ポートランドに見出している。さて日

本はどうするか。

集約、離散から自律的連携へ

　冒頭で、COVID-19のレガシーに、企業の集約から離散への働き方のリセットがある、と記した。ひとたび、無目的に無生産的に無創造的に会社に集まることを止めて一人になった（離散した）私たちは、個々のマインドセットを「労働」から「創造」へとスイッチした暁に、これまでとは違う形で、違う動機で、出自や専門分野の違う人間と再接続したくなるのではないかという期待がある。集約から離散へ、そして個々が設定した目的の達成に向かって改めて連携を図るのではないか。それは、いわゆる「つながり」動機とは似て非なる、何かに挑戦するために自立した者同士が、必要に応じて柔軟に交わり相互作用し合う共進化に向けた再接続であること、未知と出会い、関係の中で啓発を受ける人に出会い、共感し共振する

ことに対する積極的取り組みは、人生を楽しくし生きがいを実感させ、幸福をもたらすからである。都市はそうした人々の主体的かつ積極的行動を増幅させる最高の舞台であり、今後は、人が都市に求める中心的目的とはそうした活動となって欲しいと思う。

　本来、クリエイティビティとは文化芸術分野の専売特許ではない。人間誰しもが有する基本的資質の一つだ。そのクリエイティビティが、今ようやく、文化芸術から解放され、ビジネスや経済の分野、生活の質、あるいは、ウェルビーイングやハピネスといった人間の幸福追求の分野と結合し始めたと言えよう。クリエイティビティの民主化だ。いよいよ、都市を舞台に創造という生への能動的活動への取り組みが活発化し始める時と言えよう。ポートランドがそうであるように。

生物模倣法による業種多様性モール

ジーン・ボリューム・ナチュラル・キャピタル・センター

Jean Vollum Natural Capital Center

パールディストリクトの中心からやや東に行ったところにそれはある。
古いレンガ造りによるロマネスク様式の建物は、
辺り一面にエココンシャスな波動!?を放っている。
市のサステイナブル開発局、環境保護活動組織、
そしてパタゴニア等が入居する、
パールディストリクトのエコムーブメントのエピセンター（震源地）だ。

アイディア、商品、サービスが集まるところ

建物の正式名称はジーン・ボリューム・ナチュラル・キャピタル・センター。普段はナチュラル・キャピタル・センターとかビルオーナー名に由来してエコトラスト・ビルなどと呼ばれることも多い。オーナーのエコトラストとは北太平洋沿岸地域の川に戻ってくるサーモンのために地域の生態系保護活動を行っているNPO団体で、この建物内に本拠地を置く。

建物は1895年に建てられた古い倉庫で、それをエコトラストが1998年に買取り、改修を施した上で2001年に今の状態に甦らせたもの。全米で初のLEEDゴールド認証をもつ歴史的建造物の改修事例でもある。施設のコンセプトは次の通り。「環境保護活動や社会的責任ある行動に関するアイディア、商品、サービスが集まるところ。対象はコンサベーションエコノミー（今で言うところのサステイナブル経済やグリーンエコノミー）を志向する者であれば、ノンプロフィットでもプロフィット（民間企業）でも行政でも構いません」と、ナチュラル・キャピタル・センターイベント担当ディレクターのシドニー・ミードさんは語る。このまるで自然の生態系にも似た施設内の業種多様性を称して、彼らは自らの施設をオフィスビル

▼1 生物模倣法（バイオミミクリ）
自然界をモデルとし、自然の英知を真似ることにより人類が抱えている問題を解決しサステイナブルな社会を目指す、という概念。1997年に自然科学分野のライター、ジャニン・ベニュスが書いた『Biomimicry: Innovation Inspired By Nature』誌で初めて紹介された。

ジーン・ボリューム・ナチュラル・キャピタル・センター

計画概要	1895年竣工の歴史的建造物(倉庫)の環境共生型改修		
竣工	2001年9月	敷地面積	3720㎡
建築面積	1858㎡	延床面積	6500㎡
費用	1240万ドル	認証	LEED ゴールド
オーナー	エコトラスト・プロパティーズ LLC.		

でもショッピングセンターでもなく「マーケットプレイス」と呼んでいる。

入居しているテナントは、パタゴニア、ポートランド市サステイナビリティ計画局、森林保護団体、ワイルド・サーモン・センター、サステイナブル・ハーベスト、カフェ、ホットリップス・ピザ等と様々で、その多様性こそが困難な問題解決に向けての新しいアイディアやグッドヘッズ（Good Heads）が集まる必要十分条件という確信に基づいている。

「生態系が上手く機能している森を歩けば良く分るけど、多様性こそが健全の証でしょ。だから私たちはここを一つの生態系として捉えているの。合言葉は「バイオミミクリ（生物模倣法）」つまり自然の姿を真似る、ね。全体を構成する要素が多岐に及んでいる方が、総和としてもタフな身体をキープできる。だから、この再生されたビルの中でテナント同士のコミュニティが盛り上がっていく過程は、まるで自然界で植物が健全に育って実を結ぶ瞬間ともいえるわね」

それが、修辞法や大それた大口がここに聞こえないだけの雰囲気や気配がここには漂っている。1階のヒッピーライクなオーガニックピザの店ホットリップスや建物中央のアトリウム空間にたむろするボヘミアンな雰囲気の連中の存在が、エイジングした（何と115年もの歳月！）木の床や柱の空間と相まって、建物内外にリベラルで寛容で同時にクリエイティブシンキングに慣れた独特の緩さや鋭さを放っている。ビル開業時、ポートランド市長はここを称して「ポートランドのキャラクター、バリューそしてスピリットを体現している」と賞賛したという逸話も残っている。

「フォーマル、インフォーマルを問わず、建物内のコモンエリアではしょっちゅうナレッジや経験の交換が行われているわ」建物のデベロッパーでもあるエコトラストの主催により、2ヶ月に一度程の頻度でテナント同士が集まり議

▼2 パタゴニア
アメリカのアウトドアブランド。登山家であり創設者兼オーナーのイヴォン・シュイナードが1960年代より登山用品の製造販売活動をスタート。以降、クライミング、スキー、スノーボード、サーフィン、フライフィッシング等アウトドア用品の製造販売会社として成長。環境保護活動に熱心なことでも知られる

▼3 ポートランド市サステイナビリティ計画局
同局は自然環境保全、地域経済の活性、市民生活の質向上の実現を目指して、持続可能性のある開発や土地利用計画を執り行う市の部署。全スタッフ約120名の内50名がここエコトラストビル内の分室に勤務している

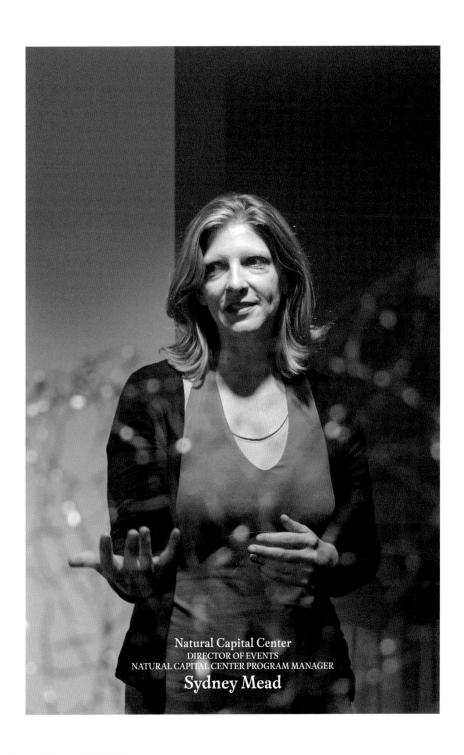

Natural Capital Center
DIRECTOR OF EVENTS
NATURAL CAPITAL CENTER PROGRAM MANAGER
Sydney Mead

論を交わすビルディングギャザリングも実施しているという。文字通りこの建物が経済的活力やエコアクティビティ機会、ソーシャルキャピタル等が集まり育成される震源地として機能しているのだ。

「パールにおけるファーマーズマーケットは、もちろんここが会場よ」

エコムーブメントの
エピセンター（震源地）

「何か新しいことをただ破壊しさえすればいいというものではない。グッドシングスは革命からではなく、進化からもたらされる」。エコトラストの創始者であり代表を務めるスペンサー・ビービーにかつてそう助言したのは、あのジェイン・ジェイコブスだ。スペンサーは一九九一年にエコトラストを立ち上げ、それから約10年近くに亘ってアラスカからサンフランシスコに及ぶ太平洋沿岸地域のウィルダネスを舞台に生

態系保護活動を精力的に行ってきた。ところが90年代後半、エコトラストのボードメンバーを勤めていたジェイン・ジェイコブスの強い勧めを受けて、活動の舞台をウィルダネスのコミュニティ（アメリカ先住民族等）からアーバンネイバーフッドのコミュニティへと移す決断を下したのである。

「都市文明を維持していくには農地や森林や河川の存在が不可欠。その重要性を都市に暮らす人々が認識し、当事者意識をもって責任ある行動をとるようになることこそが急務である」

ジェインがそう気付かせてくれたという。そこでスペンサーは本腰を入れて活動に取り組むために、資金を集め建物を自ら所有することで現実に都市コミュニティの一員となることを決心した。スペンサーの考えた施設のコンセプトは、誰もが自由に出入り可能な社会に対して開かれた場所＝マーケットプレイスの創出。さほどエコ活動に興味がなく、単にランチにピザを食べ

▼4 ワイルドサーモンセンター
環太平洋地域における野生の鮭、鱒、ニジマスの生態系に関する調査研究と保護活動を行っている公益法人。活動領域は当然のことながら、太平洋から遡上する河川、そして河川を守る森林、つまり内陸部の原野にまで至る。

▼5 サステイナブルハーベスト
持続可能な農業の実現を目指し、有機コーヒー豆のフェアトレードを行なっている団体。アジアやアフリカ、中南米の零細コーヒー農家から買上げ、国内とカナダの焙煎業者、スーパーマーケットに卸している。

▼6 スペンサー・ビービー
エコトラスト代表。ポートランダー4代目。長年に渡りコンサベーション・インターナショナ

に来た人でも、中で行われているハプニングやイベントに接したり、2階で開かれているワークショップやライブラリーをのぞくことで、何らかの刺激を受け関心をもつことにつながる、という期待がある。2008年、2階にある貸会議室の稼働実績は478回と記録されている。

「Good Heads」と新しいアイディアを集めて結合する、再創造を促す。それが

よりよき未来に向けた、些細ではあるけれど進歩につながるアクションではないだろうか」。かつてジェインとスペンサーが想い描いたビジョンである。

私の感じたナチュラル・キャピタル・センターの周り一面に漂うエコカッティングエッジな空気とは、果たしてジェインの放つオーラだったのかも知れない。

「リレーションシップ・コーヒー」。サステイナブル・ハーベスト社のコーヒー豆のブランド名。今、消費者は購入した食材がどこから来ているのかを知りたがっている。同様に、生産者も栽培した農作物を誰が食べてくれているのかに関心がある。両者が親密になることで、豊かになれることは沢山あるという考えに基づいている

ル及びネイチャー・コンサーバンシー（いずれも世界有数の環境保護団体NGO）に所属し、ウィルダネスを対象に自然保護活動に従事。1991年らエコトラストを立ち上げ、活動の舞台を都市（における環境保護活動）に移した。エコトラスト・カナダのボードメンバーでもある。

2階のシェアオフィス光景。写真はサステイ
ナブル・ハーベスト社。賃料は周辺と比べ
て決して安くはないというが、現在オフィス
は満室状態で新たな募集は行なっていない
という

JEAN VOLLUM NATURAL CAPITAL CENTER RES

エコトラストのオフィス風景。地球環境問
題に関する打開策を常に探求している同組
織の企業文化は、「実践的なコンセプト立
案を優先する」。(頭でっかちなだけじゃ物事は始
まらないってこと)

1階に入居するオーガニックピザの人気店「ホットリップス」。ポートランド市内で5店舗を展開する家族経営企業だ。創業は1984年。成長ホルモンを使用していない精肉や近郊の無耕栽培を実践する小麦農家グループの小麦粉を使うなどポートランド・サステイナビリティ運動の象徴的存在。自らのウェブサイト上で使用する総ての食材の生産者名を公開している。とはいえ人気の要因はそこに有らず。食べてみれば一目瞭然だ。いやー"舌"瞭然か

1階中央に設けられたコモンスペース。奥に
見えるのはパタゴニア

JEAN VO

> 66 もしあなたが洋服を買おうとしているのなら、
> あなたにできる最も責任ある行動とは救世軍を訪ねることです。
> もしあなたが会社を立ち上げようとしているのなら、
> あなたにできる最も責任ある行動とは古い建物を探し出し、
> それを修理して使うことです 99

パタゴニア創設者兼オーナー イヴォン・シュイナードによる
ナチュラル・キャピタル・センターのオープニングパーティでのコメント

アーバン・グリーン・マーケット

ポートランド・ファーマーズ・マーケット
Portland Farmers Market

ポートランドでは毎年3月から12月にかけて、市内5カ所にて
ファーマーズ・マーケットが開催される。スタートは1992年、わずか13の出店者で
こぢんまりと始まったこの試みも、18年目を迎える今日では、200を超す出店者が集い、
年商600万ドルに達するポートランダーの生活になくてはならないものとして定着した。
以下にPFM（ポートランド・ファーマーズ・マーケット）運営主体が発行する
2009年版アニュアルレポートをつまみ食いしてみよう。

▼1 市内5カ所

マーケット会場は、月・
水・木・土・日の各曜
日によって市内5カ所
に振り分けられている。
ダウンタウンの中心に
位置するパイオニア・
コートハウス・スクエア
は月曜日、パールディス
トリクト内のエコトラス
トは木曜日といった風。
最も規模が大きいのは、
土曜日のポートランド
州立大学で、地元民か
ら旅行者までが大勢詰
めかける。

パールディストリクト内におけるファーマーズマーケットはエコトラストビルが舞台

Q1

PFMって何?

PFMはファーマーズ・マーケットの運営を通して、地元の作物生産者を支援し、地域経済を活性化させるとともに、コミュニティに拠り所を提供することを使命としている。その他、次の役割を担っている。

- ビジネス・インキュベート
- ローカルフード運動の先導役
- 栄養学・社会衛生・農業の保全を学ぶ拠点
- ごちそうの中心地、音楽イベント付きの文化的ディスティネーション(目的地)
- ポートランドのサステイナブル運動の象徴

Q2

ところでPFMって誰?

- 年間契約のスタッフとボランティアによるボードメンバーで構成された小規模NPO
- オレゴン州とワシントン州から参加する225の農家・生産者の集まり
- 出店の条件は、

・自身が所有、あるいは運営する農場で100%育てた作物をもつ地元農家。

・環境に負荷をかけない飼育・栽培・収穫方法を採用している農家・職人的な優れた品質へのこだわりとプレゼンテーション力の持ち主

Q3

なぜファーマーズ・マーケットなのか?

- 地元の食材は美味しい上に、消費者の健康にとってより良いものだから
- 地元の食材は地域本来の生物多様性を維持することにつながるから
- 地元の食材は地元の家族と仲間の生活を応援することにつながるから

168

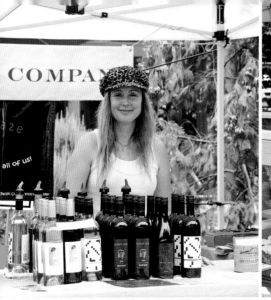

Q4

もう一度同じ質問。なぜファーマーズ・マーケットなのか？

◐ 地元の食材は（乱暴な農地拡大を防ぎ）オープン・スペースを維持するから
◐ 地元の食材には消費税がかからないから
◐ 地元の食材は環境浄化に寄与し、野生動物の生息地を荒らさないから
◐ 地元の食材は未来を担っているから
◐ 地元の食材は安全だから
◐ 地元の食材は（そしてPFMは）楽しいから

◐ 地元の食材（の集まるPFM）はコミュニティの形成につながるから

Q5

PFMの実績データは？

◐ 開催地はポートランド都市部の5カ所
◐ 年間来場者数は約53万5千人
◐ 出店者は農家、養殖家の他、パン、花卉、チーズ、菓子等の生産者、計250団体
◐ 年間開催日数は延べ約100日間
◐ 年間約60名のボランティアが延べ1200時間を提供

Q6

PFMのもう一つの使命は？

◐ 消費者と地元生産者を直接結びつける
◐ 都市と郊外（生産者）双方のコミュニティの絆を深める
◐ 地元で生産された食物を食べることが、いかに私たちのためになるか、周知を図る

以上の活動によって、私たちの地元生産者を応援すること。

出典：ANNUAL REPORT 2009

都市成長境界線（UGB）の恵み

▼1 ファーム・トゥ・テーブル・レストラン

Farm to Table Restaurant

成長ホルモンを使用した畜産品お断り。飼料はオーガニック。家畜のクオリティ・オブ・ライフを尊重した飼育環境。生態系を脅かす乱獲をしない漁業。野菜は旬の物しか使わない。エコロジカル・コレクトネス。食品の安心安全。ローカルビジネスの経済的支援……。理由はいろいろあろうが、でも一番の理由は、美味しいものにありつきたいから。

▼2 サステイナブル・キュイジーヌ

大企業によるチェーンストア以上に独立系ローカルビジネスが幅を利かせるここポートランドでは、飲食店においてその傾向は一層顕著だ。

「ここは他の都市と比べてワン・オフィス・ビジネス（1店舗だけの規模の企業）がとても多んだけど、それはポートランダーのアンチチェーンストア志向、地元企業優先の気質に支えられてるんだ」（ジョシュア・ライアン／PDBA エグゼクティブ・ディレクター）。

レストランの場合、それは地元の農家、畜産家、漁師たちを尊重し地元食材を優先的に使用するスタイルとなって現れる。もちろんその方が市民たちも嬉しいからだ。レストランオーナーの元を訪ねると、皆一様に自らの契約農家自慢が始まる始末。こちらはそれ程英語が堪能でないにも関わらず……。

ポートランドのこうした食の傾向は特に「ファーム・トゥ・テーブル」や▼3「FLOSSムーブメント」と呼ばれ定着している。ピザハウスもビアハウスも例外では無い。その背景には、市内から車で少し走ると肥沃な農地や太平洋に辿り着くことができるという、あのUGB政策に依るところが大きい。

▼1 ファーム・トゥ・テーブル・レストラン
地元食材（ファーム）を使用して（テーブルに）提供する米国版地産地消の意。都市の近郊に豊かな農地や漁場をもつこと、元々地元意識が強いこと、そして何よりも美味しい味とはどんなものかを知っている人が多いこと。これがファーム・トゥ・テーブル・レストランが歓迎される理由。

それが「人口一人当たりのレストラン数が全米一」「レストランを開業するならポートランド」と囁かれる所以ともなっている。

ここで、かつて村上春樹がポートランドの食について、ある会員誌に書いた文章を引用する。「ポートランドのめぼしいレストランに入ってまず気が付くのは、食材の生き生きとした質の高さだ。こればかりはニューヨークやロサンジェルスのレストランには真似のできないことだろう。使われている野菜や肉や魚の大半は、すぐそのへんでとれた新鮮なものである。しかしただ新鮮なだけではない。レストラン経営者やシェフたちは、自分の目で食材をいちいち吟味している。彼らの多くは農家や牧場と契約を結び、有機農法を用いた食材だけを使うように気を遣っている。そこまでの細かい目配りができるのは、何といっても地元の強さである。」(「二つのポートランド〈前編〉」『Agora』March 2008から抜粋)。

調理に手を加え過ぎないのがファーム・トゥ・テーブル・レストランの特徴

▼2 サステイナブル・キュイジーヌ

食材の持続可能な供給を考慮に入れた料理、またはそうした料理を出すレストランを指す。サステイナブル・リソース主義も同意。使用する素材は自ずと、種の保存や生態系の維持に自覚的な生産者のものとなる。こうしたレストラン事業者は、多店舗化にあまり関心のないことが多い。

▼3 FLOSSムーブメント

Fresh Local Organic Seasonal Sustainable フレッシュローカルオーガニックシーズナルサステイナブルの略。FLOSSな食材を使用することで地域経済と生態系及び自然環境保全に寄与し、いつでもいつまでもクオリティの高い外食体験を享受しようという運動。

米国で嬉しいのは、グラスに注がれる飲み物の量。
メルローでもエールでも満々と注がれる。
「堪能すること最優先」。
楽しめば楽しむほど、
それをもたらしてくれる自然が愛しくなる。

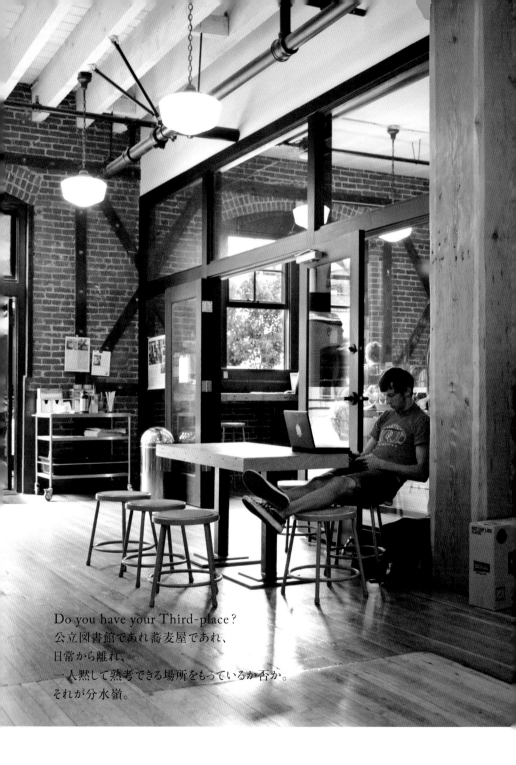

Do you have your Third-place?
公立図書館であれ蕎麦屋であれ、
日常から離れ、
一人黙して熟考できる場所をもっているか否か。
それが分水嶺。

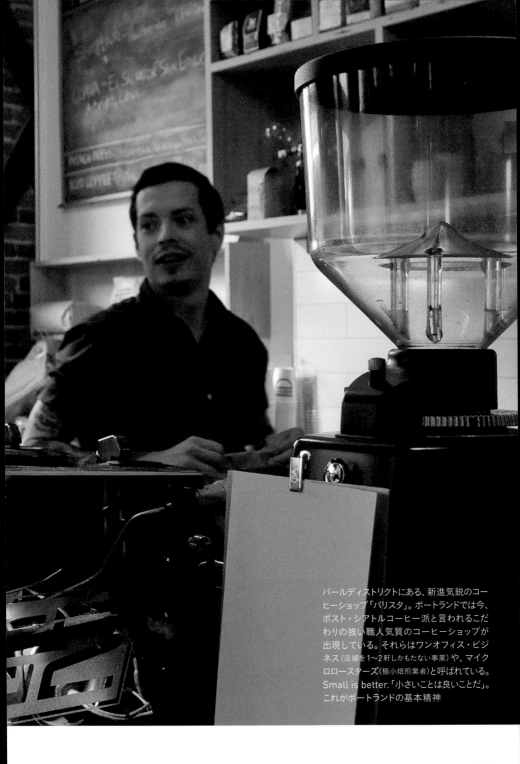

パールディストリクトにある、新進気鋭のコーヒーショップ「バリスタ」。ポートランドでは今、ポスト・シアトルコーヒー派と言われるこだわりの強い職人気質のコーヒーショップが出現している。それらはワンオフィス・ビジネス（店舗を1〜2軒しかもたない事業）や、マイクロロースターズ（極小焙煎業者）と呼ばれている。Small is better.「小さいことは良いことだ」。これがポートランドの基本精神

ファーストサーズデイの当日、パールディス
トリクト内のあるギャラリーのアートピース
は自転車であった

自転車工房の聖地
フレームビルダー

バイク・セントリック・シティ
Bike Centric City

米国で最もバイクフレンドリーな都市ポートランド（米国国勢調査局による調査）はまた、
求道的でインディペンデントな自転車工房の聖地でもある。
ある人曰く、「ここはまったくイタリアみたいなとこさ。
人々ときたら皆、どこに行くにも自転車なんだから」。
そんな地元フレームビルダーの中から、愛すべき4組を紹介する。
いずれも自由で革新的な精神の持ち主ばかりだ。

Vanilla
Bicycles

owner
Sacha White

Company Profile

組み立てのプロ、ペインティングのプロ、木工・皮・布・金物の職人たち、写真家、作家……。「バニラの工房はまさに一つのコミュニティのよう。そしてその中心にいるのが、デザイナー兼フレームビルダーであるオーナー、サシャ・ホワイト氏だ。

サシャ氏は1999年の冬にポートランドで自転車づくりを開始。サイクリスト、クラフツマンの経験で培った独自のテイスト、ビジョン、ハードワークを武器にストイックに作品に反映させる、次世代自転車ビルダーのパイオニア的存在だ。

「バニラ立ち上げの時から胸に決めていたのは、ラジカルなアイディアをカタチにしてやろうってこと。それは単にフレームづくりに限ったことじゃなくて、自転車にまつわるすべての次元に及ぶ。マテリアルのイノベーションだったり、新しいコンセプトだったり、ユニークなコラボレーションを試すことだったりね。僕はクラフツマンはもちろんのこと、フォトグラファーやグラフィックデザイナー、できれば作家たちとも一緒になって自転車づくりをすべきだと信じている。古い慣例を破って最高の作品をつくり上げるためにね」

──サシャ・ホワイト
バニラ・バイシクルズ　オーナー

Vanilla Bicycles

photo：Bob Huff Photo

Signal cycles

owner
Matt Cardinal &
Nate Meschke

Company Profile

シグナル・サイクルズはマッ
ト・カーディナル氏とネイト・
メシュケ氏によるポートラ
ンドが本拠地の自転車メー
カーだ。冷たい雨が降り続く
パシフィック・ノースウエス
トの冬は彼らの工房をも例外
なく凍てつかせるが、灯り続
けるトーチランプと止まない
ヤスリ掛けのおかげで、彼ら
が寒さを感じることはないと
いう。

エキゾチックな場所に誘う
自転車、あるいはレース場を
駆け抜ける美しい自転車をつ
くり上げるために、二人の情
熱は彼らの手と頭をフル回転
させて止まない。

photo : Benji Wagner
photo : Daniel Paisley
photo : Benji Wagner

Signal cycles

photo : Daniel Paisley

「僕らは二人とも、子どもの頃から自転車と絵を描くことが大好きだったんだ。だから二人でバイクショップの仕事を見つけたのさ。何年もレンチとナットを相手に格闘した後、僕らはアートスクールに行くことに決めたんだ。僕らなりにグッドアイディアだと確信したね。そこでは二人ともファインアートの絵画を学んだよ。そして卒業して気付いたのさ、二人ともバイクショップを始めるのに、もう準備は完璧に整ったってね。シグナル・サイクルズは二人のクリエイティブな情熱から生まれたもの。自転車こそが僕らの答えなんだ」

—— マット・カーディナル
ネイト・メシック
シグナル・サイクルズ共同経営者

「僕が自転車づくりを始めたのは、
サイクリングを日常生活の一部に
したかったからさ。
自転車は仕事やトラベルに最適さ。
でも一番は、乗る人の生活が
もっと実践的になることだと思う。
僕はより使いやすくて、
よりエレガントで、より永遠な
自転車をつくるために、
現代のマテリアルと伝統的な手法を
掛け合わせることに関心がある」

「最高のフィット感を
達成するためには、
あらゆる可変性を考慮に入れながら、
独特の試行錯誤を試す必要がある。
そこには方程式も存在しないんだ」

ミッチ・プライオール
マップ・バイシクルズ オーナー

MAP
Bicycles
owner
Mitch Pryor

Company Profile

マップ・バイシクルズはフ
レームビルダーのミッチ・プ
ライオール氏のブランド。か
つてビルダー兼ペインティン
グのカリスマ、ダグ・ファティッ
ク氏に師事したというフレー
ムビルダーにはたまらない
経歴をもつ。2009年の
NAHBSで「ベストシティ
バイク賞」を受賞。既に優れ
たハンドメイドのスチール・
バイクビルダーとして、ポー
トランドでは一目置かれる存
在。

▼1 NAHBS
North American Handmade
Bicycle Show
世界中からフレームビルダーが集ま
る展示交流イベント。

MAP Bicycles

AHEARNE CYCLES

owner
Joseph Ahearne

Company Profile

ジョセフ・アヒアルネ氏は独創的でかつ知的で美しいデザインのスチール製カスタムバイクのつくり手として知られている。彼はクラシカルなものから突飛なタイプまで、エレガントなものからエキセントリックなものまで、あらゆるタイプの自転車を手掛けるが、すべての作品のあらゆるフレームに、彼のプライドは宿っているという。ジョセフ氏は、そのエレガントな構造、高いレベルのクラフツマンシップ、細心の注意が払われたディティールによって既に堅固たる地位を築いているが、その証拠に、2007年、2008年のNAHMB

「自転車は人類が享受できる最も輝かしい発明品の一つだ。人生は平凡な自転車に乗るには、あまりにも短過ぎると私は思うし、〈自転車に〉何ができるのか、〈自転車とは〉そもそも何か、どうあるべきなのか、について探求するのに終わりはないと思っている。だから私は真に偉大なる自転車のカタチを見つけ出そうと、毎日もがいている」

―― ジョセフ・アヒアルネ
アヒアルネ・サイクルズ オーナー

で、彼は「ベストシティバイク」賞を受賞している。

自転車の機能上の課題の多くは、独創的なデザインチャレンジによって解決されることが少なくないが、ジョセフ氏はこのデザインチャレンジと問題解決にむけた創造性の発揮に特別のこだわりをもつ。

このこだわりについて、彼はよくバックミンスター・フラーを引用してこういう。

「問題に直面した時、私は美しさについて一切の関心を払わない。私は唯問題の解決方法についてのみを考える。しかし、それが終了した時、もしもその姿が美しくはなかった場合、その方法は誤りであることを、わたしは知っている」

真夏の夜の市街地レース

Portland Twilight Criterium
ポートランド・トワイライト・クリテリウム

イベント時に配られた
応援用カウベル

毎年恒例の真夏の夜の夢

　世界屈指の自転車都市ポートランドを象徴する毎年夏の夜（しかもフライデーナイト）の恒例イベントがポートランド・トワイライト・クリテリウム（ポートランド公道自転車レース）だ。　2009年は不況の影響でスポンサーの撤退が相次ぎ一旦は開催中止に追い込まれたものの、地元レースファンの尽力で資金源を何とか確保（スバルアメリカ、地元弁護士事務所等が協賛）し、見事開催に漕ぎ着けた。

　競技は都心の公道を閉鎖してつくった一周約800mの6コーナーサーキットを全米中から集まったトップレベルのプロライダーが駆け抜けていくレース。勝敗は制限時間内の周回数で決まる。

　レース当日は、夕方4時の道路閉鎖と同時にサーキット内に設けられた野外フードコート、ビアガーデンがオープン。オレゴ

ンで盛んなハンドビルダー（自転車工房）による展示会やインディーズバンドによるクールな演奏（何とオルタナティブロック!)で盛り上がった6時30分、最初のレースがスタート。

　レースは3つのカテゴリー別に夜8時30分まで続く。各カテゴリー毎の出場者数は最大80名。目の前30cm先をカッ飛んで行くライダーの群れがもたらす風圧は、見る者を圧倒する。主催者によれば毎年1.5万人の観客がこの真夏の夜の夢を楽しんでいるという。

　同じ市街地レースでも、モナコグランプリよりインディペンデントで、シンガポールグランプリよりもエココンシャスな、このポートランド・トワイライト・クリテリウムは、シャンパンよりもエールビールがよく似合う。

「全米で最も自転車通勤者の多い都市」「自
転車フレームビルダーの聖地」。何かと自転
車との縁の深いポートランダーは毎年夏に
開催されるこの市街地レースをとても楽し
みにしている

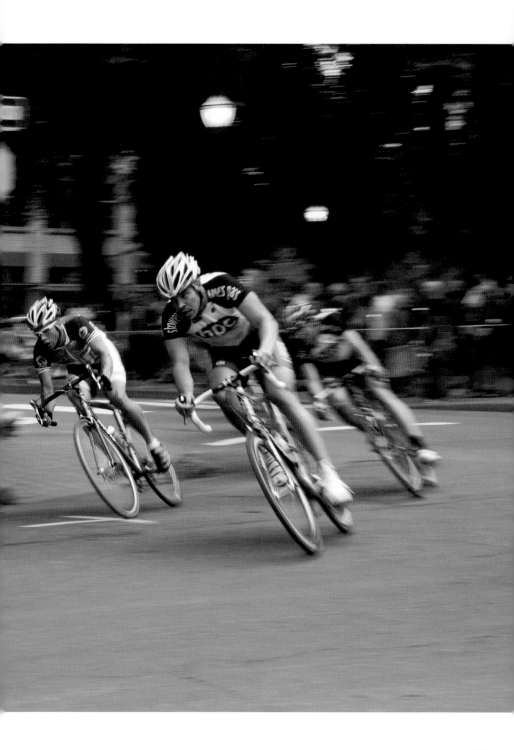

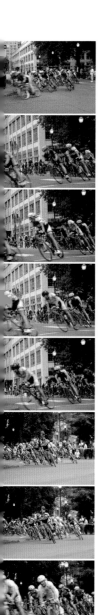

**North Park Blocks
Downtown
Portland**

4:00 pm
Beer Garden
Food Court
Bike Show

6:30 pm
Racing begins！

モナコグランプリより
インディペンデントで、
シンガポールグランプリよりも
エコフレンドリーな市街地レース。

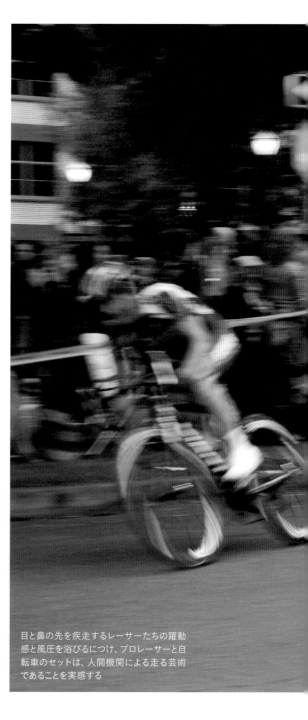

目と鼻の先を疾走するレーサーたちの躍動
感と風圧を浴びるにつけ、プロレーサーと自
転車のセットは、人間機関による走る芸術
であることを実感する

Handmade Bike Exhibition

　写真はいずれもレースと同時開催された
「ハンドメイド・バイク・エキシビション」
の光景。左ページの自転車「スピードバー
ゲン」は、バニラ・サイクルズ社サシャ・ホ
ワイト氏の手によるもの。NAHBS（ノース
アメリカ・ハンドメイド・バイシクル・ショー）で
2005年、2006年2年連続ベストアワード
を手中に収めた、新世代フレームビルダー
のカリスマだ。納車は数年先とか。上写真
は RENOVO 社による話題の木製フレー
ムバイク。ウォールナットとシダーのコン
ビや、パドウク（本花梨）、ウエンジ材とメイ
プルのコンビはエレキギターの名器を彷
彿させる。リーズナブルな竹製フレームの
「Panda」シリーズもある。

ブックラバーたちの聖地

City of Books Powell's Books
シティ・オブ・ブックス パウエルズブックス

インディーズ精神の象徴的存在

パールディストリクトのランドマークであり、ポートランド・ブックラバーたちのメッカがここパウエルズブックス・バーンサイド店だ。開業は1971年、総面積7.7万sqf(7,200㎡)の同店は全米で最も大規模なインディペンデント系書店として知られる。店の特徴は新刊書と古書、単行本と文庫本(ペーパーバック)がいずれも同じ棚に隣り合って並んでいる点。お客は本の取得ニーズの違い(と、もちろんお財布事情)に応じて、同じタイトルの本でもハードカバーから古書のペーパーバックまで、最適なタイプを選択することができる。売り場はカテゴリー別に7つのゾーンに分かれており、各々が分かりやすいようにカラーリングで区別されてはいる。が、渋谷東急ハンズのようなスキップフロア構造は、初心者を必ずや迷わせることだろう。でも心配無用。熱心で知識豊富な店員たちが優しく迷い子をリードしてくれること請け合いだ(何を読むべきかが分らない、深刻な迷子も含めて!)。

フロアガイドと店内でみつけた
ZINE（同人誌）たち。ポートランド
はZINEづくりが盛んなことでも知
られる。退屈な商業誌を読む（見
る？）よりは、仲間とディープインタ
レストなZINEをつくった方がまだ
マシ、ということか

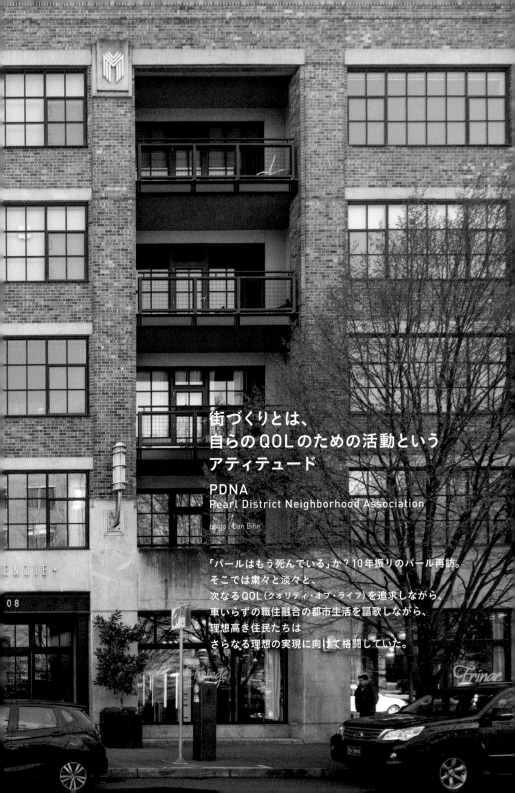

街づくりとは、
自らのQOLのための活動という
アティテュード

PDNA
Pearl District Neighborhood Association

photo : Dan Bihn

「パールはもう死んでいる」か？10年振りのパール再訪。
そこでは粛々と淡々と、
次なるQOL（クオリティ・オブ・ライフ）を追求しながら、
車いらずの職住融合の都市生活を謳歌しながら、
理想高き住民たちは
さらなる理想の実現に向けて格闘していた。

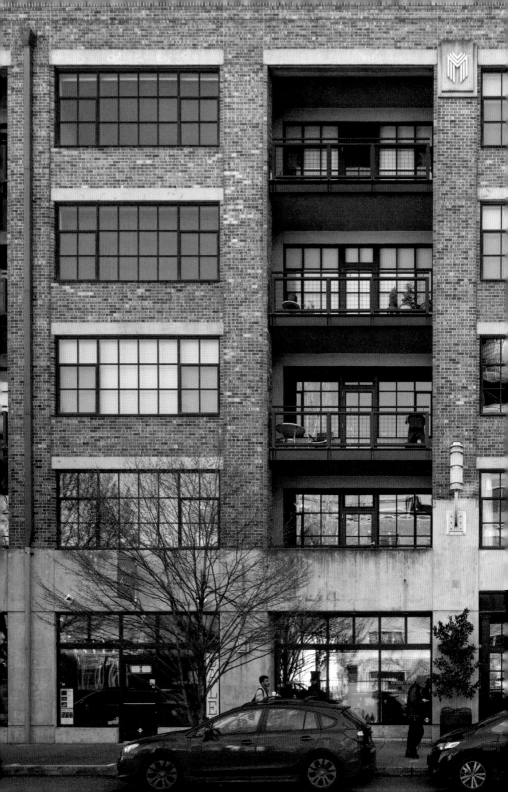

「コミュニティが生まれるかどうか
は、建物以外のすべてのことの方が大
切だ」と語ったのは、パールディスト
リクト開発に携わったデベロッパーだ。
ミクストユーズ、多様性、セレンディ
ピティの要素を備え、全米における都
市再生史上最大の奇跡とも言われる
パールディストリクト。その、再生され
た街は今どのような状況にあるのか。同
地区の街の維持・活性化に取り組む
PDNA（パールディストリクト・ネイバー
フッド・アソシエイション）のプレジデン
ト、スタンレー・ペンキン氏に、開発
開始から20年経った現在のパールディ
ストリクトについて話を伺った。

パールがパールであり続けるために

　2018年現在、パールディストリ
クトの人口は7千人、ビジネスワーカー
2万人。このネイバーフッドのQOL
を支えるNPO、PDNAは、代表、
副代表、その他執行役、理事の延べ24

人で構成される。年齢層は30代〜70代
までと幅広く、メンバーは広報、都市
計画、交通などの専門委員会に属して
いる。理事会と委員会はそれぞれ毎月
1回の頻度で開催されるというから、会
議以外のその他の活動を含めると、ほ
とんどは仕事を持ちながら参加するメ
ンバーとしてはかなり忙しい。「もちろ
ん無関心な人はいます。特に最近新し
い居住者も増え、コミュニティを1つ
にまとめるのは難しくなっているのは
確かです」とペンキン氏は話す。都市
として急成長中であるポートランドに
おいて、ここ数年の間で、地価の上昇、
アフォーダブル住宅の不足（賃貸住宅の
家賃は全米を通して横ばいの中、ポートラン
ドをはじめシアトル、バンクーバーの価格が
高騰）、交通渋滞などの課題が顕在化し
ている。最近は特に賃貸マンションが
増え、短期間で住処を変える人が多く
なり、コミュニティとは疎遠の人も多
く見られるようになったという。「われ
われが一番心配しているのは、このま

ま進めば、単なるアメリカのよくある大都市の1つになってしまうのではないか、ということです」

人気はやがて試練となる

　現在、パールは複数のマンション開発が進むいわゆるクレーンタウンの様相を呈している。建設工事による道路封鎖が至るところで発生し、生活に支障を来たしつつあるらしい。ペンキン氏は現状を「パールの開発は手に負えなくなっている」ともらす。さらに今、

パールに新たな問題が持ち上がっているという。それはパール北東部の川沿い、フリーモントブリッジのたもとに建設されようとしている1棟の高層ビルだ。フリーモントブリッジは1973年に8千4百万ドルを費やして完成したポートランドで最も高価なアートである（と言われている）。その橋の姿を遮ってしまう今回の開発計画に対し市が許可を下したのだ。これは景観面だけの問題ではなく、ウォーターフロントエリアの利用という点でもパール住民としては納得のいかない計画だ。元々パー

PDNAプレジデント
スタンレー・ペンキン

ルは川とのつながりを大切にするとい
うのが開発ビジョンに謳われていた。と
ころがこのビルが建つことでルールが
なし崩し的に崩れ、川沿いの魅力が失
われてしまう。また、隣接するアイコ
ニックな古い倉庫の撤去、再開発の可
能性も出てくるため、美しい橋の借景
と共にあるパールの生活が背の高い壁
で一面覆われてしまう恐れが現実味を
帯びてきたのだ。それは住民の望む姿
ではない。そこでPDNAは次なる策
に出た。まず、土地利用に詳しい弁護
士を雇い、市に建設許可に対する抗議
を申し入れ、計画の見直しを呼びかけ
た。住民には問題をわかりやすく記載
したパンフレットを配布、かかる費用
はクラウドファンディングにより集め
る、という内容だ。ペンキン氏は言う。
「私は高層ビルが嫌いなのではなく、適
切な場所に建てられるべきだと思うの
です」。パールと言えばジェントリフィ
ケーション地区というイメージがある
が、実はここにあるマンションの3割

程はアフォーダブル住宅で、パールは
必ずしも高所得者層の街ではないとい
う。問題のビルは高層マンションのた
め、一般的な市場価格で売り出される
ことが予想されるため、ポートランド
が今抱えている住宅不足問題（特に低所
得者層の住宅不足）を解決することにはな
らない。PDNAが力を入れるリバビ
リティとはかけ離れるのである。

政治的に先進的で哲学的

そんなペンキン氏は、実は生まれも
育ちもニューヨーク。夫人共々旅行好き
でアートの蒐集が趣味、穏やかで落ち
着いた物腰の紳士だ。彼がパールに住
み始めたのは2003年。以前から
ポートランドに住んでいた娘に会うた
め何度もポートランドを訪れるうちに、
街の事情に詳しくなり、その魅力に惹
かれ、ついにポートランドに住むこと
になった。「ある時、NYの生活はトゥー
マッチだと思うようになりました。ポー

トランドは時間の流れがゆっくりで、高いQOLが望めます。政治的に先進的で哲学的な面はNYに似ています」。大学では都市開発のエンジニアリングで修士を取り、NYで不動産開発に携わってきたペンキン氏は、ポートランドに住むならパール、と最初から決めていたそうだ。

開発に関する専門知識があり冷静なペンキン氏であるが、今回の物議を醸している案件の今後が別の意味でも気にかかると言う。「1度このような計画を許可してしまうと他のネイバーフッドにも同じ問題が連鎖していくのです」。こうした広い視野を持つ姿勢はPDNAの他の取り組みにも共通する。PDNAでは今、力を入れている社会実験がある。最近とみに道で目につくようになったタバコのポイ捨てを封じるために、エリア内に灰皿を設置する取り組みだ。集めたタバコのフィルターをリサイクルに回すこともできる仕組みだという。パール発祥のこの仕組みがポートランド市全体に広がるように なって欲しいと語る。

コミュニティづくりの戦略

PDNAのこのような課題に対する姿勢やポジティブな動きはどのようなマインドセットから湧いて来るのだろう、と改めて思う。「他のネイバーフッドとの一番の違いは、ポートランドで最も都心にあるアーバンのネイバーフッドであること。その特徴として、建物も住人もミクストユースであて、建物も住人もミクストユースである点はポートランドで随一と言えるでしょう。メンバーは高度な専門職に就いている人も多く、各々の知識を利用しながら、その経験をわが街に生かそうとコミュニティ内でネットワーキングを行い、フォワードシンキングでエリアを良くしていきたいという思いで動いています」。ポートランドとはいえ、95あるネイバーフッドの中にはメンバーがほとんどおらず、活発に機能し

ていないものもあるという。とは言え、最も都心のネイバーフッドだからという理由だけで、誇りを持ち積極的な活動ができるものなのだろうか。

今年1月半ば、PDNAは恒例となっているメンバー全員参加のリトリートを行なった。年に1度の食べて、飲んで、話して、楽しく過ごそうという時間だ。ペンキン氏はこう言う。「個人的にリトリートは戦略的ワークショップだと思っているのです。われわれの向かうべきゴール、そのために今するべきこと、大切にしたいことなどを3時間かけてわいわいと話し合う絶好の機会です」。決して大それたものではなく、とても草の根的でシンプルな戦略だ。それはパールで暮らすこと

に対する思いの共有とでも言えばいいのだろうか。忘れてはならないのは、彼らの活動は地域のためにしているのではないということ。自らのQOLのため、という考え方がベースになっている。魅力的なコミュニティを作るためには、住人一人ひとりの当事者意識を上げること以上の戦略はない。それ以外にパールに何かがあるとしたら、それはパールマジック。きっとあなたもパールを歩き、食事をし、人々と交わり、日本に帰ってから数日後にジワジワとそのマジックを感じることができるだろう。

「このコミュニティに興味を持ってくれてありがとう」とペンキン氏。自分が住む場所を心から愛している人からしか発せられない言葉だ。

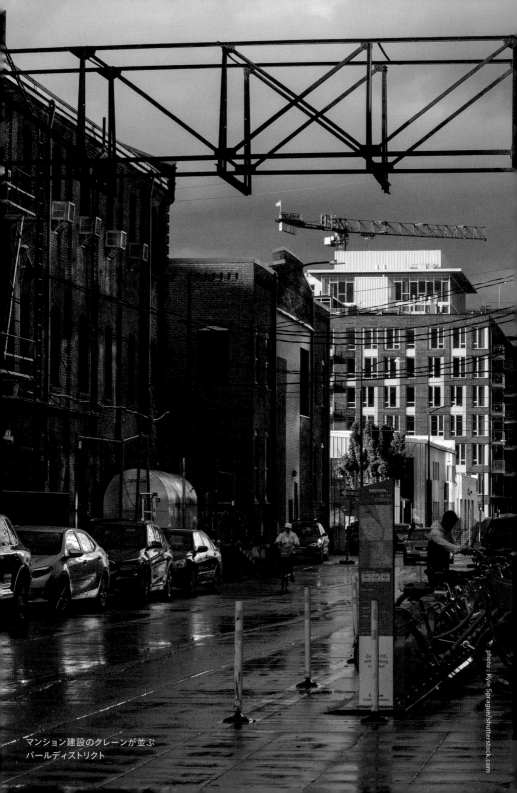

マンション建設のクレーンが並ぶ
パールディストリクト

パールディストリクト北東部川沿いにあるア
イコニックなロフト。マンションへの建て替
えを阻止するためにも、市のマンション開発
許可の見直しを求めている

Pacific Basin

ポートランドで最も高価なアート、「フリーモントブリッジ」

「ポートランドでは、
失敗よりも行動が当たり前。
ここは人生の
ラボみたいな場所」

Dan Bihn

photo : Dan Bihn

「何かを始めるのに年齢なんて関係ない」を実行する人物にポートランドで出会った。再生可能エネルギー・コンサルタントを職業とするダンさん。彼は60歳を目前にしたある日、「人生最後の冒険をしよう」と思い立ち、2014年12月、コロラド州フォートコリンズからポートランドに移住した。

クライアントの1人がおり、過去に数回訪れたことがあったポートランドの印象は、治安が良く住みやすい、公共交通が発達して、車無しで充分便利に暮らせること、環境先進都市であること、そしてクラフトビールが美味しいこと（全米でクラフトビールブリュワリーの数、第2位がフォートコリンズ、第1位がポートランド）。中でも職業柄、そして自身のライフスタイルとして、環境に配慮した都市であることは、移住を決める大きなポイントとなった。

フォートコリンズから乗って来たホンダの2人乗りハイブリッドカーは、地元のラジオ局に寄贈した。移住前、ただ1つ気がかりだったことは、雨が多い冬の気候のこと。太陽に恵まれたコロラドから来ると鬱になるのではないか、という不安を吹き飛ばしてくれたのは、「私は雨は大好き。全然問題ないわよ」という、日本料理店のスタッフの言葉だった。

住み始めてから気づいた街の魅力は、出会いの機会であるギャザリングやミートアップの文化が根強いこと。仕事の関係で7年間日本で暮らしたことのあるダンさん自身も、日本語で話す会を立ち上げ、今ではメンバーが700人を超える。「新しい土地で婚活もしようと思ってね」と茶目っ気たっぷりのダンさん。

もう1つの魅力は、チャレンジが当たり前という気風。「自分はこれがしたいという想いを持っていたら、とにかくやってみる人がたくさんいる。失敗するかもしれないけど、それは当たり前のこと。多くの人がそうしてるから、自分もしないと変な気がする。人生一度きりだしね」。

新たな魅力の反面、意外だったのは、環境面では当初感じていたよりもまだ発展の余地ありという点。専門である再生可能エネルギー分野で特に顕著なその状況は、逆に仕事の受注につながったため、「ある意味ラッキーだった」。

そんなダンさんのポートランド生活の舞台はパール地区。冷蔵庫は近くのスーパー、必要なものはほとんど徒歩圏内にある。パール地区の中で一番好きなエリアは、もちろんブリュワリーブロック。週4日は友人とクラフトビールのグラスを交わす。
「PC1つで仕事ができるんだから、住む場所は面白くなくちゃね」

The Rise of The Artisan Economy
アルチザンエコノミーの台頭

スモールビジネスを生み続けるポートランドの
ユニークな状況を見事に分析した一冊の書籍がある。
『ビール・トゥ・バイク、ポートランド・アルチザンエコノミー』(2010 Ooligan Press) だ。
著者の論考は分野を超えて示唆に富むのだが、何より痛快なのは全編を通して
行間からグランジロックが鳴り響いてくること。
著者であるポートランド州立大学名誉教授チャールズ・ヘイング博士に話を聞いた。

ボヘミアンクラスター

——著書を拝読しました。クラフトビールから自転車まで、次々と若い職人が出現するポートランドの状況を表す、実に適確な分析だと痛感したのですが、まず最初にヘイング教授が提唱されている「アルチザンエコノミー」とはどういう経済モデルなのか、解説してください。

ヘイング教授〈H〉 まず明確にしておきたいのは、マスプロダクション型エコノミーとアルチザン型エコノミーとは長い間、互いに隣り合わせのように存在してきたということです。そしてアルチザン型エコノミーモデルが将来のモデルとして今後より顕著となると私は考えています。その理由は数多くありますが、一つにはアルチザン型産業と世界とがインターネットによってつながったことにあります。なぜなら

アルチザン型産業には価値観を共有し相互に支え合う小さなコミュニティがいくつも生まれる可能性を持っているからです。インターネットのような技術革新がなければ、このようなモデルの隆盛は容易ではなかったでしょう。

——それはニッチな経済モデルではなく、資本主義社会のメインストリームになり得るということですか。

H どんな産業分野においても小規模な職人たちやグループが新しく事業を興すことは可能です。ポートランドの場合、ビール醸造が最も典型的な例です。世界のビール市場の90％以上は大手3、4社によって製造されていますが、ポートランドではクラフトビールが主要な市場を押さえていて、おそらくポートランドのビール市場の過半数はクラフトビールが占めています。この例が示すのは職人たちの持つ可能性です。これは全ての産業に言えること

Charles Heying
チャールズ・ヘイング

ポートランド州立大学名誉教授。
同大学アーバンスタディーズ及
び都市計画教授。アルチザン・
エコノミー・イニシアチブ研究長。
専門はPPP（公民連携事業）研究。
『ポートランド・アルチザン・エ
コノミー』著者

ですが、アルチザンエコノミーの可能
性というのは、ここに醸造所を作るこ
とによって、ある意味で大量生産モデ
ルを脅かす力をもつということです。

——この新しいアルチザンエコノミー
型モデルが成立する社会では、製造者
のみではなく消費者の価値観も以前と
は異なっていきそうですね。

H まず、私は「消費者」という表現
は一切用いません。消費者というのは
フォーディズム（編者注：T型フォード自
動車の製造システムに象徴される大量生産型
経済モデル）で用いられるフレームワー
クだからです。代わりに私が用いるの
はパトロンという言葉です。パトロン
は単に物を消費するという意味ではな
く、物の味や使われている材料の質、歴
史、作っている人と物との関係に感謝
する人という意味があります。各々の
パトロンが物のどの側面に感謝するか
という違いはありますが、ただ必要な

財を手に入れて消費するというよりは、
質や深み、豊かさが感じられる物を選
ぶという点では共通しています。こう
した中でパトロンと製造者との関係は
より複雑になっていき、やがてサステナ
イビリティと深く関連するようになり
ます。というのも、その複雑な関係の
中で両者は、物を誰が作っているのか、
それを製造する労働者はどういった扱
いを受けているのか、材料はどこから
来て、その出自は倫理的に問題がない
のか、材料と製造者の関係はどうかと
いうことを考えるようになるからです。

——教授はそれを資本主義社会の全体
的な流れになると捉えていらっしゃる
のでしょうか。それとも、社会の一部
でそうした動きが顕著になるとお考え
でしょうか。

H いくつかの場所ではそうした流れ
への準備ができていますし、そうした
流れへの受容力のある場所もあります。

ポートランドは人々がまとまって、こうした流れを小さなところから試すのに適した場所であり、適した人々なのだと推測できる理由がいくつもあります。1960年代のポートランドは再生・再発見の時期でした。その頃のポートランドはある種、ヒッピーの本拠地みたいな場所だったのです。

——現実的にはアルチザンエコノミーはポートランド特有の現象であるということですか。

H　その現象が起こる場所がポートランドであったことは、偶然だったのかもしれません。お伝えしたいのは、この現象はポートランドだけではなく、世界の他の場所でも起こっているということです。私はそうした場所を「Hot Artisan Spot」と呼んでいます。たとえばスコットランドのグラスゴー、ニューヨークのブルックリン、テキサス州のオースティンなどです。このような小さなボヘミアンクラスターは世界中にたくさんあるのですが、市単位ではありません。ポートランドの特異なところはそこにあります。ポートランドではある種、街全体がこの現象に関わっているように見えますが、他ではボヘミアンクラスター単位での動きです。

グランジーでファンキーであること

——ヘイング教授は世界中の主要都市が、やがてこうした経済モデルに移行していくとお考えですか。

H　世界中です。一つ例を挙げます。4年前の夏、私の甥がアイオワ州オーウェンという小さな街の郊外にある醸造所で仕事を得ました。オーウェンという街は決して恵まれた場所ではなく、人口は1万人程度で今は減少の一途をたどっています。その小さな街で、何もないところからいきなり地ビールの醸造所が現れたのです。この街はカレッジタウンなので、職人や小さなベンチャーを支える環境があります。この小さな街の一角でこうした現象が現れるのです。世界中でこうした現象が起こっても不思議ではないでしょう。

米国では、雇用が不確実であるために、労働者は新しい価値を生み出すことを強要されるか、自らその機会を利用します。そのため、一方ではリスクテイカーになるように強要されますが、もう一方では新しい試みを起こす機会が与えられるということでもあります。

——パトロンというのは審美眼に優れ文化的価値に対しての見識に溢れ、一方アルチザンは凝ることに求心的です。それはとてもスノブな社会だと思います。そうした現象は本当に主流になり得るのでしょうか。

H　まず一つ明確にしておきたいので、私はこのモデルが理想であるか

ANY JOB,
BIG OR SMALL;
DO IT RIGHT,
OR NOT AT
ALL.

RED CLOUDS COLLECTIV

HANDCRAFTED IN PORTLAND OREGON U

アルチザンリテイラー
「RED CLOUDS COLLECTIVE」

のように言うつもりはありません。このモデルから疎外された環境の中で生きている人もいます。問題は彼らがその生き方を自ら選んだのか、強制的に選ばされたのかということです。一部の人はその生き方を自ら選び、それに崇高ささえ見出しています。このモデルを広げるということをお話しするにあたり、この点だけはあらかじめ明確にしておきたいと思います。

——選択肢の一つとして広まるであろうと。

H　ええ。ではどう広めていくかということに話を戻しましょう。まず市が始めることとして、経済成長は大規模会議施設や大規模交通インフラなどの、大規模開発ありきという発想から抜け出すことです。これらが必要ないわけではなく、開発投資が繁栄の唯一の方法であるという思考から脱却することです。ではその代わりにどうするか。大金が動く大規模プロジェクトの目線から、人々が実際に仕事をしている小規模の、草の根の、ミクロの、ネイバーフッドのレベルに目線を合わせるのです。

——ニューディール的にカンフル剤を処方するのではなく、自由主義的な小さな政府の有り様ですね。

H　市やデベロッパーの役割の中には二つあります。アルチザンたちの中にはきちんと組織だっていない人たちがいます。中世のギルドのように互いにつながる術を持っていない人たちです。市やデベロッパーはアルチザンたちを互いにつなげるサポートをすることができる、これが一つです。もう一つはスタートアップベンチャーに対して補助金を与え、彼らのビジネスを見守ることです。アルチザンには多くのクリエイティブなアイディアがありますが、彼らはそれを用いてビジネスで利益を生み出す術に長けているとは限りません。彼らを支援するコストは大規模プロジェクトと比べれば微々たるものです。それはまるで市が市民に対して投資しているようにも見えることでしょう。もちろん、こうしたスタートアップベンチャーの多くは成功しないでしょうから、リスクは多分にあります。しかし、そのうちいくつかは成功しますし、その成功が市にとって大きなアドバンテージとなります。

——いわゆるシードファンドですね。アイディアとやる気と可能性のある人間に初期段階での支援活動を行う。日本の場合、銀行内にもなかなか目利きがいない昨今、地方自治体には余計難しいような気がしますが。

H　そこはエンジェル投資やVCなど外部の力を借りればいい。それより、ポートランドや他のボヘミアンネイバーフッドが抱える問題が一つありま

す。そうした街がアーティストにとっての中心地になるにつれ、それ以外の人々がそこに集まってきます。消費の世界の目利きたちです。

そうした人々が移り住めば、たちまち家賃が上がり、アーティストたちは住めなくなってしまいます。ですから、街をいかにファンキーなままに保ち、景観やベンチなどを「過度にキレイで素敵にしない」かを考えなくてはなりません。街をある意味でグランジーに保っておかなければ、その街は死んでしまいます。吹田さんはパールディストリクトがお好きだとおっしゃっていますが、私はあまり好きではありません。なぜなら私にとってあそこはグランジーではなく、段々と高所得者層向けになってきているからです。

デベロッパーはアーティストたちが移り住んだ後にやってきて、彼らを追い出し、そこに高層ビルを建てますね。私は彼らのやっていることを非難したりはしませんが、街をいかにファンキー

に、グランジーに、気取らなく、ストリート感覚に配慮しながら保つかということは実に難しい問題です。

（編集部注：旧ポートランド市開発公社。PDC
2017年プロスパー・ポートランドに組織改編）はある意味で相反する事業を行っています。ポートランドにはもっとグランジーさが必要です。

——そういうグランジーなところからしかイノベーションは起こりにくいということはよく分かります。かつてのパンク精神やガレージスピリット、昨今のハックカルチャーなんかがそうですね。石貼りの高層オフィスビルからは、「0から1」は生まれない。

「骨折りと苦労」と「喜びと楽しみ」

H　もう1つお話しておきたいのは、パールディストリクトはキレイになっ

たとはいえ、未だに活気溢れる場所だということです。市もデベロッパーも多額の投資をしていますし、デベロッパーの多くがアートを愛し、さらにいくつかのデベロッパーは早い段階からネイバーフッドで生まれるスモールビジネスの価値を理解していました。たとえば、いまのNorthwest23rdの活気を生み出した人物はアートのパトロンです。彼は多くの不動産を購入して地区を掌握し、その地区を生き生きとした場所に作り上げました。同時に彼はサステナビリティに強い関心を持つデベロッパーの一人でもありますが、「グリーンなデベ」と喧伝するために環境配慮に上辺だけ取り組む「green washing」ではありません。彼らは自分たちの未来を見据え、与えられた機会に対して意欲的であり、またクリエイティブに自らの意思で環境に配慮した建物を開発しています。そうしたアーキテクトやデベロッパーはアルチザンと同様に真のクラフトマンです。彼らの建物も

また1つの作品であり、アルチザンたちと同じ考えの下につくられています。もちろん、それによって利益を生み出してはいますが、同じようにして利益を得たいのはアルチザンであれ、ギャングのグラフィティ作品映画であれ、自ら何かを生み出しているアンダーグラウンドな世界というのはありますか。

——もちろんあります。しかし印象論ですが東京の場合、ポートランドに比べて、そういう人の人口に対する割合は低いように思えます。東京には自分の関心テーマを探求するため、実現するためというよりは、企業に就職するために移り住む人が圧倒的だからです。その結果、都市は創造の場ではなく消費の場となりがちです。労働はいつまでも「骨折りと苦労」であり、アルチザ

吹田さんに一つ質問があります。東京にはポートランドにあるようなグランジーさ、つまり人々が音楽であれ、自

H　そうですね。ポートランドではお互いがお互いを知っています。街を歩けば誰か知っている人に出くわさないことはない程、小さな街です。その小さな街の中でアルチザンは互いに物やアイディアをやり取りし、互いのショーアイディアをやり取りし、互いのショータイルの方がよほど重要なのです。

ンのように「喜びと楽しみ」という境地にはなかなか至らない。それはある種、大都市の宿命ではないでしょうか。

H　そうですね。本の中で書いたことですが、ポートランドのパトロンは何かを得るために別の何かを犠牲にすることを疎んじません。美味しいコーヒーを飲むためなら、車は古いトヨタ車でも構わないのです。ポートランドでは車よりも他のこと、たとえばライフスタイルの方がよほど重要なのです。

と、その違いに気づかされます。

ちです。一方ポートランドの人たちは、特にクリエイティブな人たちは、自ら実現したい明確なゴールや目的がまずあって、それを達成するために必要に応じて、スキルやアイディアや道具を交換するために人と「つながる」んだ

——日本では人と「つながる」こと自体に比重が置かれメインテーマとなりが

H　そう願っています。本でも書きましたが、これは「より大きな経済」の話ではなく「より良い経済」の話なので

る街です。

いうネイバーフッド単位で成立しているに顔を出したりします。ポートランドはお互いがお互いを知っている、そう

「より大きな経済」と
「より良い経済」

——頭ではその価値は分かるのですが、現実問題としてアルチザンエコノミー社会が広がっていくと、その国のGDPは下がりませんか。

す。

2009年開業のコーヒーショップ
「BARISTA」

エコトラストビル

コーヒーロースターのラボ内光景

「コミュニティエンゲージメント」テーマのミートアップイベント光景

――「より大きな経済」は悪い経済ですか。

どうバランスを取っていけるでしょうか。この辺りをいとは言えないですよね。この辺りを

H　GDPは指標としてはあまりに不十分です。GDPはあくまで撹拌度合いを測る指標なのです。

――それでは、今の時代ではどういった指標を用いるのが適切か、お考えはありますか。

H　アルチザン経済では、GDPに代わる新たな指標を考えなければなりません。もしかしたら測る事自体がフォーディズム（大量生産型）経済のやることで、そもそも測る必要など無いのかもしれません。

――市政府は税収増につながる大企業の進出を望みますよね。他方で小さなアルチザンがいることは生活を豊かにはしてくれるかもしれませんが、税収入は減り、都市経営にとっては好まし

H　私が思う所のPDC（前述・旧ポートランド市開発公社。2017年プロスパーポートランドに組織改編）がどうあるべきか、という点についてお話します。まず、エコノミストを雇わないことです。私には彼らがお金を再生産させているだけのように思えてならない。それは戦略ではありますが、決して目指すべきゴールではありません。では、どうすればいいか。PDCはまず自らのモデル全体を解体する必要があります。現在のファンドの流れを止めるべきです。TIF▼1を止めるということは法制度を変えるということであり、向かう方向を変えるということであり、資金の流れを変えるということです。

PDCのような経済開発のための機構がするべきことは、自らの構造維持のために働くことではなく、ただ街を見て「この街をより良くするためには

▼1 TIF
（Tax Increment Financing）
特定地域の都市再生事業を、再生事業効果により将来的に生まれる租税増加分を担保とした起債発行資金で賄う都市再生手法。州法で制定されている。

いずれも製造工場を併設する
小売店、アーバンマニュファ
クチュラー

どうするべきか、皆が恩恵を受けられる公平な街にするためにはどうするべきか」、「綺麗なネイバーフッドを新しく作るのではなく、今あるネイバーフッドがよりその中の人々のためになるにはどうするべきか」、「新しくモノや建物を作らないでより良くするためにはどうするべきか」を考えることです。「今の計画をどう台無しにしてやろうか」を考えてもいいですね。

PDCは今行っていることをこれからも続けるでしょう。そしてそれは今のポートランドの形を害し、ポートランドをディズニーランドに変えてしまう可能性を持っています。すみません、まったく曖昧な説明になってしまいましたね。

吹田注：2017年6月、PDC（ポートランド市開発公社）はこれまで行ってきた都市再生がもたらした弊害である社会的課題に取り組むために、活動方針の転換および組織改編を行い、新たにプロスパーポートランドとして再出発した。ヘイング教授の指摘がまさに現実のものとなった。

ミニ・マス・プロダクション

——ヘイング教授が提唱されている、アルチザンエコノミーの骨子となる概念、「ミニ・マス・プロダクション」についてご説明頂けますか。

H 「ミニ・マス・プロダクション」は今ではよく見かけるもので、今後研究を深めていきたいと考えているテーマの一つです。ディープ・マニュファクチュアリングという、小さいけれど一つのジャンルに特化した製品を比較的短期で少量製造するビジネスモデルがあります。ミニ・マス・プロダクションとは、同一ジャンルの複数のディープ・マニュファクチュアリング・メーカーが製品を供給し続けることにより、やがて市場を形成していく状況を指し

ます。

——ポートランドの例で言うと、クラフトビールなんか、まさにそうですね。

H　今日の製品を作るための工作機械のコストと活用機会の柔軟性について考えてみましょう。現在、工作機械の価格は製造コストの低下により相当安くなりました。かつてハンマーはとても高価な道具でしたが、今ではハンマーを手に入れられない人はいません。同じことが高度な工作機械にも言えます。たとえば金属を裁断するプログラミング入力可能なレーザーカッター。ポートランドでは5千ドルのレーザーカッターを購入して金属の加工を行う2人のアーティストチームがいます。それから曲げ加工機、クリッピング加工機、ドリル機などの機械も比較的容易に入手可能です。これが小規模な製造業に独自の、アルチザン然としたモノづくりの可能性を生み出します。そして実際にそうした専門的な製品には大きな需要が生まれるだけでなく、多様な製品によって需要はさらに持続するのです。

——でも、ミニ・マス・プロダクションでは、大企業の生産ラインに比べ、生産に携わる就労者の数は圧倒的に少ないですよね。雇用をあまり生み出してはくれませんね。

H　労働市場に関して言えば、少なくとも米国において労働者・労働力はより柔軟になってきています。それも組織的に柔軟になってきています。現在、企業の存在はアーティストたちのクラスターの周りを囲う、ある種の「殻」のようなものになりつつあり、とてももろく、束縛が弱く、だから同時に作りやすいものなのです。ある日突然一つの良いアイディアが生まれ、そこに人や資金が集まり、一つの大きな企業となります。とても弱い拘束性がありな

からも非常にフレキシブルで境界線が希薄です。

　労働者はその柔軟性に適応していかなければなりません。そしてそれは生活の不安定さにつながります。しかし、歴史的に見ても新興企業というものは経済的に最も不安定な組織です。安定性が強まるとその組織の競争力は低くなってしまいますから。今では経済全体がとても不安定かつ柔軟になっていて、これらのことが常に起こっていると私は考えています。それがクリエイティビティにつながり、同時に不安定性にもつながります。もしかしたらクリエイティビティと不安定性はコインの表裏と言えるかもしれません。

　これは私の想像ですが、若い世代はそのような環境の方が居心地良いと感じている気もします。だから若い世代があまり子どもを持たないのかもしれません。自分たちが安心して子どもを育てられると思える、安定した環境を得たことがありませんからね。

　──僕はそうした状況が必ずしも社会的悪だとは思いません。少なくともその環境では風通しの良さと機会の平等については尊重されているでしょうから。ポートランドは他の先進都市と比べて少しだけ早くこうした状況が顕在化したのではないでしょうか。その意味でも、やはりポートランドはちょっと特殊ですね。

H　私は、それは「西海岸的なもの(coastal thing)」だと考えています。スタートアップ企業とVCのエコシステムができているサンフランシスコ郊外のシリコンバレーではこうした状況はよく見られます。マイクロソフトやボーイング等大企業のあるシアトルではそこまでではないかもしれません。

　──先ほどヘイング教授は今後人々の働き方が変わるとおっしゃっていましたが、消費者、いや失礼パトロンの方との付き合い方が変わるのではないでしょうか。たとえば、物との付き合い方が変わるのではないでしょうか。

H　場所や人との関係がより多く生まれ、人は自然と自分が好きな場所へとつながっていきます。言い換えれば、フレッドマイヤーのスーパーマーケット（編集部注：ポートランド発祥のスーパーマーケット）に心動かされることはなくとも、ポートランドのコーヒーショップには心動かされることがある、ということです。そうした変化によって、ローカルな企業は増えていくかもしれませんし、またより重要視されていくかもしれません。そしてその勢いはフレッドマイヤーのような大規模チェーンにも変化をもたらします。フレッドマイヤーはポートランダーの生活環境に徐々に責任を持ち始めます。ワインやデリカテッセン等において地元の生産者（アルチザン）たちとの関わりを取り戻そうとします。もしかしたらこの試みは成功するかもしれません。というのも、ポートランダーがほかの街に出かけていくとフレッドマイヤーが

なくてホームシックになってしまう、という話を聞いたことがあるからです。私には全く意味がわかりませんが。

もう一つ、昔あった形がいま再び現れている例として、人と人（PtoP）とのやり取りがあります。ポートランドでは多くのPtoPのやり取りが起こっています。たとえばレンタカー。それまではレンタカーショップで車を借りるものでしたが、今ではiPhoneで赤の他人どうしが車の貸し借りを行っており、そのための仕組みができています。空いてる部屋のオーナーとそれを欲している旅行者とをつなぐAirbnbも一つの例として挙げられます。iPhoneアプリも同様です。最近、私はあるiPhoneアプリのプラットフォーム製作者からこの街のキュレーターにならないかと誘われました。私が個人的に書いている自転車のブログのように、似た趣味嗜好を持つ人々のネットワークのキュレーターを求めていたのです。人々はそのネットワーク内でモノやアイディアなど、ありとあらゆるものを交換することができます。このネットワークによって、アルチザンは製品をiPhoneで販売できるようになり、またそれらは全てローカルなものです。ローカルを一つの価値ある単位と見なすキュレーターがいて、それらを集めるのです。これがもう一つのモデルです。

大きなバイヤーを解体し、市場がよりフラットな形になることで、P2P化が進むのです。ですから、人々が互いにモノを売り買いする状況において、我々はもはやフレッドマイヤーを必要としなくなるのです。

同じようにアプリで私設車道を駐車場として貸し出したり、広告スペースに貸し出したり、道具を貸し出したり共有したりすることができます。こうして道具を共有し合うことで道具を購入する必要がなくなります。これが製造共有の経済「maker-sharing economy」です。 共有できるものの数は無制限です。

——そうした重層的で多様な関係性が成立する都市においては、街の形そのものも変わってくるのではないでしょうか。

多く与えるほど多く成功する

H　私たちはいま、変革の只中にいるのかもしれません。私たちにとって馴染みのある構造、たとえばPSU（ポートランド州立大学）のような大きな教育機関がどうなるのか、これまで行ってきた機能を果たすのか、今この時点では私にもわかりません。ただ、私が最近大学の教職員と議論していることがあります。それは、本来大きな教育機関の意味は経済学部、理工学部といった同じ探求テーマを持つ人々を集めることにありました。しかし、事ここに至り、人々がどこでも好きにバーチャルに集うことができるなかで、人々を集める意味はあるのかという問題です。も

はやこうした旧態然とした教育機関は必要ないのではないでしょうか。同じ探求テーマを持つ人々をただ集めるだけでなく、PSUのような教育機関が本来提供できる多ジャンルに及ぶナレッジを、学部の分け隔てなく提供する技術的環境が既に整っている時代に、それをしないことの損失はどれほどになるのでしょうか。

大学の存在は直接人と会って議論する機会を与えてくれますが、それにしても私たちはいま変化の時を迎えているのだと思います。

暮らしに目を向けてみると、仕事場に暮らすという変化が挙げられます。かつての産業革命は全てを分離しました。デザイナーと仕事を、住居スペースと仕事場を、商業エリアと工業エリアを、全てを分離しました。ところが今は元のように融合しつつあります。小売店が入居する建物に工房スペースを持つことができ、住居も作ることができる。まさにミクストユーズですね。

今いるこの大学の建物もその変化の良い例です。商業スペースが下の階にあり、教師たちの執務スペースがその上の階にあり、その他のスペースは貸しスペースになっていて、さらに交通インフラが建物群の真っ只中を走り抜けている。主要交通インフラが大学の校舎群の真っ只中を横切るような光景を誰が想像したでしょうか。これが私が説明している変化の始まりです。交通が道に留まらず、住宅が住宅地に留まらない。まさに変革の只中に私たちは立ち会っているのです。

これは一晩で成し遂げられることではありません。ある都市計画プランナーが言っていたことですが、計画したものの90％は既にそこにあって、プランナーにとっての挑戦とは残った数少ない余白部分で何をするかを考えることなのだそうです。吹田さんはこの世界の新しい形をどう見て、どう対応していますか？

――複雑に絡まった課題の解決策を考えるにも、新たな価値創造を行うにしても、0から1を生むためには、分野横断的、仕事と生活というワーク・ライフ融合的な生き方が求められると思います。ポートランドのディープマニュファクチュアリングたちはよく、職人、詩人、ミュージシャン、カメラマン、スケートボーダーなどの多種に及ぶ才能が集まって起業するケースが多いですよね。もちろん彼らは元より仲の良い友人たちだったのでしょうが、一緒にものづくりのブランドを立ち上げなくてもいいはず。彼らは本能的に新しいアイディアはカオスの中からしか生まれないと気づいているのだと思います。

街中がポットラックパーティ

H　では行政主体が街を秩序あるカオス環境に仕立て上げるために必要なことを考えてみましょう。まず、コンパクトにデザインされたゾーニングがあ

クラフトディスティラリー「Bull Run Distilling Co.」

ポートランド州立大学内を走るストリートカー

ります。私たちは既にそれをパールディストリクトで目にしていますね。歩行者や自転車が通りやすい交通環境、「20分圏ネイバーフッド」などです。これは都市生活の質に関わる必要なものです。さらに、公園など誰もが利用できる空間も必要です。

　我々は本来、私の呼ぶところの社会的富という集合的な富を欲しています。これからの時代、我々には個人の富よりもこの社会的富がより重要性を増してきます。それは都市に雰囲気(ambience) を、生活 (livelihood) を、つながり (engagement) を生み出します。この街のデザイナーたちに話を聞くと、必要なほとんどのものが自転車や徒歩、そしてネイバーフッド内にあって、すぐにアクセスできることが大事なことの一つだと教えてくれます。

　ポートランドでは人々が道具をシェアすることができるシェアファクトリーなどの集合的な富（場）を開発しています。溶接・鉄加工・木材加工・グラフィックデザイン等が一つの建物の中にあり、少しの料金を支払うだけで、共同オフィススペースやデザインビルドのスペースを使用できます。これは決してテクノロジー分野のスタートアッププベンチャー専用の施設ではありません。独立したてのデザイナーからリタイヤしたシニアにまで広く開かれた施設です。こうした場と機会がこの街に増え始めています。

　これらの社会的富によって人々がより少ない持ち物で、よりシンプルに生きられるようになります。多くの人がポートランドに惹かれる理由はここにあると私は思います。特に若い人々にとっては、貧しいながらもより良い生活を実現できるからです。ポートランドは、街中をポットラックパーティをやっているようなものです。

　そうした環境の下では、まずはアルチザンたちが率先して、自らの技術と資源を潜在的な競争相手と共有することを始めます。その方が革新を促す健全な競争が生まれ、結果として得るものが多いという事実にいち早く気づいたからです。彼らは競争 (competition) ではなく共創 (collaboration) を優先するのです。やがてそうした慣習は一般市民にまで浸透していきます。同様の感覚をもつ創造的な人々をこの街は引きつけるからです。知識が自由に共有され、誰もが自身の創造的なアイディアを追求する開放的で協働的な態度が街に広がっていきます。

　その時、大量生産時代の役務としての労働という概念により、いったん分離されてしまった仕事と生活が、アルチザンエコノミー下の創造的社会において再統合するようになります。生活、仕事、社交の境界が楽しくぼやける地域社会が生まれるのです。

　以上が今、ポートランドで起こっているアルチザンエコノミーです。その意味で、ポートランドは都市経済の変革における開拓者でもあるのです。

人間資本のエンパワメント

——アルチザンがもたらした市民レベルでの創造的な社会が、市民に「消費に対する意味の再定義」を促し、それがアルチザンたちを評価し、吟味し、支援するマインドの醸成へとつながり、そうした都市環境下において初めて審美性、有限性やサステイナビリティと相性の良いアルチザンエコノミーが機能するようになる。

それは遊休資産をインターネットを使って課金流動化するシェアリングエコノミーとは一線を画すものであるという理解を得ました。

事業化・金銭化、つまり洗練されたビジネスモデルが先か、あるいは人間資本のエンパワメントが先か、どうやらポートランドは後者の方で、その意味で、ここはよりプリミティブなガッツがあり、時にファンキーで、欲望に対して素直に向き合っている気がします。人間の創造性とは実はそこにあるのではないかとさえ感じます。

さらに、備忘録的に押さえておくな

らば、生活の質と創造性とは表裏一体の関係にあること、創造性追求を優先する都市においては、自立のための連携がデフォルトであること。逆は不可なり。ポートランドは都市がいち早く「消費都市」から「生産〈創造〉都市」へと体質変容を果たした革新的チェンジメーカーであること、そこにアルチザンエコノミーが立脚していることを再認識できました。ヘイング教授、本日はありがとうございました。

Happiness
by Creativity
Mitsuhiro Yamazaki × Ryohei Suita

ハピネス・バイ・クリエイティビティ
山崎満広×吹田良平

2010年に『グリーンネイバーフッド』を出版してしばらくして、ポートランドからある行政マンが訪ねてきた。ホテルで対面し、なぜか一瞬で馬があった。山崎満広さんである。それから折に触れては一緒にビールを飲んでいる。今回改めて増補改訂版を出すにあたり、ポートランドに加え日本での都市計画ビジネスに取り組んでいる彼と、かの地を客観視しながら日本の都市開発や地方創生の課題と可能性を語り合う好機だと思った。テーマは経済開発、関係の質、そして創造性とした。創造性の地平の上では、生産性とハピネスが同時にかなう、というビジョンが見えてきた。

<div style="text-align:right">photo : Yusuke Komiya</div>

Profile
山崎満広 Mitsuhiro Yamazaki

Mitsu Yamazaki LLC代表。1995年に渡米しサザンミシシッピ大学で経済開発修士号を取得。ポートランド市を含む全米各地で都市開発に従事。2017年にサステナブルな地域経済をデザインするコンサルタントとして起業。2019年より東京に拠点を移し、国内外のプロジェクトを手がける。横浜国立大学客員教授、Ziba Design国際戦略ディレクター、つくば市顧問、神戸ウォーターフロント開発機構アドバイザーなどを兼任。

We Build Green Cities Portland から10年

吹田　ビールはたまに一緒に飲むけど、こうした企画での対談は初めてですね。

山崎　初めてお会いしたのが、僕がまだ、PDC（ポートランド市開発公社）で、対外経済戦略に従事していた2012年ですよね。2019年に日本に帰国して、今では都市計画コンサルタントをしていますが、振り返ってみると早10年になります。

吹田　一緒にポートランドのサステイナブル志向の都市開発手法そのものを日本に輸出しようと「We Build Green Cities Portland」チームを組成してカンファレンスを主催したのが、2013年。それがきっかけかどうかわかりませんが、にわかにポートランド流生活の質が日本で少しずつ取り上げられるようになりました。

山崎　その節はありがとうございました。「エ

コディストリクト」というコンセプトで、都市計画家から、ランドスケープアーキテクト、ゼロエミッションエンジニアまで巻き込んで、当時世界でも最高レベルのポートランド発のカーボンフリー型都市開発タスクフォースを組んで、ツアーをしましたね。

吹田　ようやく、少々過剰とも言えるポートランド熱もおさまったこのタイミングで、いよいよ、日本のサステイナブルデベロップメントに向けて、具体的にポートランドのエッセンスを生かす時だと思い、お声がけさせていただきました。

山崎　光栄です。私も日本に軸足を移し、おかげさまで北海道から沖縄まで、街づくりに関するご相談を頂くにつれ、いろいろと感じるところがありますので、本日はそれを吐き出せたならと思い来ました。

吹田　「経済成長」、「ネットワーキング」、それから「クリエイティビティ」の各テーマについて、日々感じている課題と克服のヒン

トをポートランドを糧に探っていきたいと思います。

経済成長とサステイナビリティ

吹田　先ほど、私は「日本のサステイナブルデベロップメントに向けて」、と言いましたが、どうも日本には、経済成長とサステイナビリティとを二律背反の関係として見る風潮が一部にある。そこにとても違和感を感じます。持続可能な成長なきところには、雇用需要も賃金上昇も、ましてや生活の質の追求も有り得ない、というのが持論です。でも、これだけで、「贈与経済でやりくりできる。その方がより人間らしい暮らしが実現する」という反論が聞こえてきそうです。

山崎　自治体から街づくりの相談を受けた場合、僕たちは、まず地域経済の分析から着手します。医者の診断に例えると分かりやすいんですが、地域において、経済分野ではこの部分に問題があって、コミュニティ形成分野においてはこの部分、アーバンプ

ランニングにおいてはこの部分に問題があ
る、と診断をした上で、それら課題を克服するための処方箋を練っていきます。それが、皆が合意できる将来ビジョンの骨格となるわけですが、中でも僕たちが最も重視するのは地域経済なんです。

吹田　ホッコリとしたコミュニティ論よりも、まずは地域経営の基盤となる産業と金流から診断するわけですね。

山崎　ポートランドのパールディストリクトにおいても、サステイナビリティと経済成長を両立できたから、全米で最も成功した都市再生と言われるわけで、どちらかだけでは再生とは言えません。例えば、今携わっている北陸地方のある案件では、町の周辺の山林を基盤とした製材業が地域産業として相対的に際立っていることがわかりました。もちろん前途洋々な産業ではありませんが、そうした地域固有の資産を把握することによって、どんなジャンルとコラボレーションすればどんな新しいビジネス

228

山崎満広

を作れるかというビジネス戦略を打ち立てることができます。さらに一歩踏み込んで新事業をプロデュースするお手伝いも可能となる。全ては地域経済がエンジンとなって、その振興のために施設は何が必要か、どんなコミュニティを作ればいいか、自治体予算をどう考えるかと視野を広げていくわけです。

吹田　最初に重視すべきは、ウォーカビリティでもなければ、関係人口作りでも、ましてやコミュニティ論でもない。まずは、地域の産業振興が起点だと。ただし経済成長がゴールだと言っているのではなく、その基盤が作れてこその外貨獲得のための場所の整備やイベント開催だし、リサイクルや生活の質を考える余地も生まれてくる。地球環境の持続性は地域経営の持続性から、という順番の話をしているに過ぎないですよね。

山崎　はい。今の時代、サステイナブルデベロップメント（持続的開発）やエコノミックデベロップメント（経済成長）を、成長と捉

えるよりも振興と捉えた方がいいのかもしれません。成長となると、プレイヤーたる企業が、相手を打ち負かしてでも、社員の生活を無視してでも、環境に負荷をかけても利益追求のために突っ走る、結果として格差が生じることを肯定することになり兼ねません。一方、経済振興だと、産業のバラエティを豊かにする、ビジネスの多様性を拡大することと解釈できます。そこに、新たなプレイヤー参画の余地も雇用も付加価値創造も包含されますから。

吹田　なるほど。新たな財やサービスは既存の事業会社よりもベンチャー企業から生まれやすい、だから起業支援を手厚くするスタートアップ振興策と重なりますね。スタートアップ拠点都市では創造性が尊ばれる。具体的には、いわゆるエコシステムを構成するプレイヤーたちと、彼らが相互作用しやすい環境と、彼らが縦横無尽に接続しやすい機会や触媒機能を整備する必要があるんだけど、それが整った街では個々のケイパビリティが上がり、その結果、モビ

吹田良平

リティも生産性も上がる。目指すのは、そちらの方ですね。さて、その場合、日本ではもう一つ克服しなければいけない障害があります。ネットワーキングです。

山崎 その前に、このトピックの中で話しておいたほうがいいと思うんですが、帰国して常々感じるのが、日本の自治体のマネーに対するクリエイティビティの低さです。

吹田 PDCはそもそも、TIF（Tax Increment Financing）の運用主幹でもありましたから資金調達、資金運用、つまりマネーに対するリテラシーが高い。

山崎 TIFの話ではありませんが、例えば、PDC自体にはそれほど予算はありません。その代わり、どこにどのように投資をすれば経済が活発になるか、あるいは、どこに潤沢な資金があるかは知り尽くしています。極論を言えば、それを掴むために日夜、人と会っているようなものです。でも、ケースバイケースで両者をマッチングする

のはPDCの仕事ではありません。それは金融機関の仕事です。PDCが行政機関として行うのは、融資に積極的な金融機関や機関投資家からお金を集めて、地域経済を活発にするための原資となる公的ファンドを組成して、伸びる企業に融資することです。もちろん、その際の厳格なルールは成文化して用意してあります。そこまでのプロデュースを行政機関が行っていました。

吹田 日本の自治体では、そういう機能は難しいですね。県や国から予算は取っても民間から資金を集めて戦略的ファイナンス自体を企画、実行するのは制度的にも無理だと思います。

山崎 はい、ですから日本の自治体では、担当者と面白いアイディアで盛り上がったとしても、「今は予算がないので来年度以降で」、という話になり、そのほとんどは立ち消えになります。なぜ、いつまでも上からの予算だけに頼るのでしょうか。なぜ他の予算だけに頼るのでしょうか。なぜ他の資金調達方法を工夫して編み出さないので

しょうか。不思議でなりません。

吹田　自治体での可能性は地方自治法を調べないと、私も迂闊に言えませんが、民間デベロッパーであれば、例えば、スタートアップに対して、彼らから賃料を徴収する代わりにストックオプション権を受け取るなんて方法もあり得ます。収益の上げ方一つ取ってももっと工夫の余地がある。ミッションを達成するために、各セクター共、もう一歩、前に踏み出すべきだという指摘ですね。大学発ＶＣ（ベンチャーキャピタル）だって誕生したくらいですからね。

生産的接続のすすめ

吹田　例えば、本だったり、論文だったり、カンファレンスだったり、知人との会話だったりを通して刺激を受けて、それがきっかけとなってアイディアが膨らんで一つの像を結びそうになる時ってありますよね。そうした時、その分野の先人や達人と会って直接教えを請いたい、あるいは議論をして

みたい、壁打ちしたい、と思いますよね。でも、それがなかなかできない。相手が応じてくれるはずはないと諦めてしまう。

山崎　せっかくトラクションが効いていた能動的でエネルギッシュなモチベーションが、死の谷に直面してそこで途絶えてしまうんですね。

吹田　そうなんです。せっかく発現した内なるアイディアと熱情が、次のフェーズに展開していく前に消滅してしまうんです。いつもそうなんです。その機会損失をなくすために、私たちは意識的に接続習慣を変える必要があると痛感しています。例えば、私たちは、仲間内には必要以上に気を遣って同調的に振舞おうとしますが、一旦その外に出ると、一切他人を無視するか、場合によっては敵対視すらしてしまうことがある。私たちは、相手の心情ばかりに気を掛けるのではなく、もっと知識創造の文脈で他人と接続する自由を身につけなくちゃいけない、と思うんです。

山崎　それって、新しい自治会のあり様とも言えますね。そこにいる皆がセンス・オブ・ビロンギングを共有し合って初めて、そうした自由自在なダイアローグ社会ができるのではないでしょうか。

吹田　パールディストリクトのような職住遊が融合した創造的なミクストユーズのネイバーフッド（近隣住宅街）を、郊外住宅街の典型的なネイバーフッドと区別して、アーバンネイバーフッドと名付けましたが、日本のスタートアップ拠点都市やイノベーションが創発される地区も同様に、知識創造の目的で他人と接続し合うことを善しとするコモンセンスを備えた街にならなければ、という考えです。

山崎　ということは、その街の住民だけではなく、オフィス就労者や来街者が街に滞在している朝8時頃から夜10時頃までの新しい括りでのコミュニティが対象になりますね。地域住民によるコミュニティとは明確に区別してミクストユーズならではのコ

ミュニティの質が求められるということです。そこをきちんと理解した上でないと、アーバンネイバーフッド開発はうまく行きません。

吹田　知識創造社会における、新しいビジネス街のあり様とは、そうしたアイディアのパス回しの視点で捉える必要がある。集合知です。つまり、その新しいビジネス街が機能し発展していくためには、生活の質、場の質にも増して、接続の質が非常に重要な鍵となる。私がポートランドで最も印象深かったのはそこなんです。かの地では、アイディアから工作機械に至るまで、いかにも柔軟にシェアが行われていました。

山崎　日本の都市になくて、パールディストリクトに存在するものがそれですね。例えば、パールでは、コーヒーを飲んでて他人と目が合うと、まず簡単な挨拶を交わし、それから場合によっては会話が始まります。一方、これは私に限った話ですが、東京丸の内仲通りのテラスでコーヒーを飲

んでいても人と目が合うことはありません。というか誰もが他人と目が合わないように意識的に避けているような気さえします。あるいは、ユニークな身なりをした人が来たら、向こうではそれが礼儀でもあるかのように決まって声を掛けますが、日本の場合は、見て見ぬ振りをしますよね。

吹田　そして陰で批判する。その違いは何でしょうか。単に日本人はシャイだからで済ませてしまっていいものでしょうか。ポートランドでは、会いたい人がいたとすると、だいたい友人一人か二人を介せば、辿りつけると言います。そこから、確実に物事は動き出します。

山崎　文化的要因ももちろんあるでしょうが、30年間経済が停滞したままとか、先進国で幸福度が極端に低いとかを耳にするにつけ、僕もそれで済ませておく場合ではないと思います。接続に対する心理的バリアと接続により生まれるであろう価値を天秤にかけた時、価値の方に目をつむっている

わけですから。日本では人格形成の重要な時期のほとんどを受験勉強に費やしますよね。その結果、正解だけを善とし、間違いは怖いものと認識するようになってしまった。その弊害ではないでしょうか。でも正解以外にも思いをはせることがクリエイティビティの出発点ですよね。そしてクリエイティビティとはリスクを取ることと親和性が高い。日本人が接続に不器用なのは、知的好奇心や創造性の発揮の習慣が希薄だからではないでしょうか。

吹田　偶然ですが、「ベンチャー白書2020」によると、日本で起業が少ないと考える理由について起業家に尋ねたアンケート結果の上位3つが、「失敗に対する危惧」「身近に起業家がいない」「学校教育」だったそうです。日本の奥ゆかしさは私も大好きですが、ある地域、ある場面においては意識的に接続の質を変える努力をしないと、いつまでたっても低い生産性は今のままです。加えて、正解ばかりを意識して創造性に蓋をしたまま大人になると、仕事

と遊び、オンとオフを明確に分けるようになる。自ずと仕事に遊びの要素が入る隙が無くなる。学びに遊びの要素が入る隙が無くなる。そういうシチュエーション下で、起業や社内ベンチャー、クリエイティブやイノベーションといくら叫んでみても、うーんと感じてしまいます。今こそ創造性、今こそラジカルなダイアローグだと痛感しています。対話と創造性は不可分の関係でもありますから。

創造性の発揮とハピネスの蜜月

山崎 ポートランドでは多くの人が仕事に創造性を取り入れて楽しんでいるし、ある いは好きなことを仕事にしている人も多い。 だからワークとライフを分け隔てることがないばかりか、朝目が覚めた時からもうワクワクが始まっている。日常的にクリエイティビティを発揮しているんです。

吹田 その意味で、創造性と言うOS（コンピュータのOS）の上で、仕事と遊びが統合

され、だから、どちらも等しく能動的で情熱的なものとなり、その結果、いわゆるウェルビーイングとか、ハピネスとかいう見地に近づくようになる。ハピネス・バイ・クリエイティビティ。創造的に生きる、自らの可能性の最大化に励む生き方という観点においては、創造性と幸福感は表裏一体と言えるのではないでしょうか。

山崎 ポートランドの例では、日英の翻訳家だった人が、ビール好きが高じてブルワリーを巡るツアーガイドになり、ついにはブルワリー作りの相談を受けて、開発プロデュースまで手がけてしまう。この間何と約2年。このように、何かに挑戦するという行為に対して躊躇はないし、抵抗したり足を引っ張る人も現れない。逆に、それなら誰々さんに会ったらいいよと横のつながりによるサポートも潤沢。その結果、挑戦する人はどんどん前に進んで、傍観者はあっけにとられる。やがて傍観者が挑戦する人になる。こうした光景が日常茶飯事なんです。

234

吹田　当事者は単に楽しそうだからとか、夢が膨らんで試さずにはいられないからといった理由で始めるんだと思いますが、それだと、徹夜続きでも苦にならないし、金銭的に損をしたって比較的耐性がある。そうした挑戦が仮にうまく行けば、自身に全く別の局面が開けてくる。これこそハピネス・バイ・クリエイティビティそのものですよね。かつて現地の知人が話してくれたこの言葉がとても象徴的です。「この街では、何かしたいことがあるとすると、それを現実に試してみないと、変な人だと見なされるんだ」。

山崎　正にオレゴン開拓時代、オレゴン州を目前にして、お金に目がくらんだ人は、ゴールドラッシュに湧くカリフォルニアに南下したし、新天地で事業を興そうとした人はそのままオレゴンに入植した、という歴史が物語っていますね。

吹田　こういう言い方もあります。ポートランドではアメリカンドリームは無理だけど、クオリティ・オブ・ライフは叶えられ

ると。あるいは、こんなのも。アルチザンクオリティ、リトルビットクレイジー（笑）。

さて、まだまだ語り合いたいんですが、紙幅も尽きてきました。山崎さんの経験とノウハウ、それから私の都市愛と天邪鬼精神を統合すれば、何か日本の都市再生のお役に立てそうな気がしてきました。関心のある方はお気軽にご連絡ください、という締めでいいですか。

山崎　もちろんです。僕たちはポートランドは元より、国内外から様々な課題解決のためのチームを組成して、カスタムメイドのソリューションを包括的レンジで提供することが可能です。ビジョニングやプランニングから実践プロジェクトまで、頭と身体の両方を駆使して事にあたるのが特徴です。ぜひ、ご一緒に何かお役に立てれば嬉しいです。

吹田　この近くに美味い焼鳥屋があるんだけど、行こうよ。

対談実施日：2022年7月上旬

MEZZANINE VOLUME 2
Amazon Effect meets Portland
TWO VIRGINS / 2018

おわりに

　オリジナルの『グリーンネイバーフッド』の序章に登場した、家の近くの行きつけのコの字の酒場が、2021年春、40年間掲げてきた暖簾を仕舞い、店を畳んだ。20余年通いながら、結局、店主とも店の常連たちとも多くの会話を交わすことなく、きれいにその店との蜜月を終えた。きっと代わりはすぐに見つかる。

　近年、頻繁に使われる言葉、コミュニティや交流の根底には、同じ関心を持つ人、共通点を持つ人同士でつながり、関係を深めたいという欲求が強いように思う。それでは都市にいる恩恵を生かしているとは言えない。「互いにわかりあえる人たち」の集団に閉じているのではもったいない。もちろん連帯を深めるタイプのコミュニティから得るものはあるだろう。しかし、継続的に自己変革を起こしていくためには、狭く閉じた「お約束のコミュニティ」を超えて、フロンティアに出ていく必要がある。そうでなければ、インターネットにおけるフィルターバブル問題同様、自分と同じような、想像の範囲内に収まる考え方にしか出会うことはできない。それでは、新たな関係の中で啓発を受けたり、未知と出会い共感し共振することはかなわない。そこからは幸福は程遠い。

　オリジナルの『グリーンネイバーフッド』にも登場した、作家の曽野綾子氏は名著『都会の幸福』で、次のように記している。

　「過去になかったものを遠慮なく存分に作り出していく、それ

が都市に許された使命である」。そしてこう続ける。「都会では生きているだけで教養を得ることができる」、その代わり「地方では哲学を得ることができる」。

コミュニティよりコ・ラーニング、交流より衝突といった態度の方が、都市の基本性能に則したより楽しい生き方だと思う。言うは易しだが、こうしたエートスがみなぎる街の実現はなかなか難しい。「シティ（市）」よりも二回りくらい規模が小さい「ネイバーフッド（近隣地区）」の方が実現性は高いと思う。もちろん、アーバンネイバーフッドだ（33頁参照）。増補改訂版の執筆にあたっては、そのアーバンネイバーフッドの解像度をもう一段上げて、人々のマインドセットや街のコモンセンスを解明しようと試みた。行き着いたのが、創造的ネイバーフッド（＝クリエイティブネイバーフッド）である。

この創造的ネイバーフッドとは、没頭・衝突・変化を善しとするマインドセットをベースに、ラジカルな共創と異花受粉による共進化をコモンセンスとする街である。取り組むにはまず、交流やつながりが意味するタイプの根本的差異を認識することが肝心だ。社会的包摂や相互扶助を醸成する、いわゆる社会関係資本を高める交流と、共進化をもたらす創造資本を高める交流とは性質を明確に区別して意識する必要がある。地域コミュニティ論やいわゆる、街づくりの現場で言われる「つながり」や

「関係人口」と、知的生産性を高める場である創造的ネイバーフッドで歓迎される「コ・ラーニング」や「共創人口」とは明らかに交流のタイプが異なる。創造的ネイバーフッドとは、友人づくりよりも、自分の欲望を優先し一人没頭する者に開かれた、アナーキーでラジカル、自立しているがゆえに柔軟に結合することが歓迎されるネイバーフッドなのである。以上がポートランドへの取材を通じて、今回筆者がたどり着いたゴールである。

筆者の感じるポートランドの魅力とは、地域コミュニティ論でも、街づくり論でも一切ない。この街から学んだのは、欲望とインスピレーションと挑戦のマインドセットだ。「挑戦する精神を持ち続けるということ、挑戦する人を排除せずに受け入れるということ」。さらに、「街自体が自ら率先して実験的取り組みに挑戦すること、街が挑戦する人を具体的に応援すること」。だから、彼の地は、パーパスシティであり、エイブルシティであり、オポチュニティシティであり、挑戦特区なのである。チャレンジする者はチャレンジしている街に集まる。人皆同類を好むのだ。

日本の都市を舞台に創造的ネイバーフッドを実現したい同志へ。
こちらより一報を待つ。
https://www.archinetics-inc.com/contact

2022年7月　東京 目黒にて
吹田良平

吹田良平
Ryohei Suita

(株) アーキネティクス代表取締役、MEZZANINE 編集長 1963年生まれ。大学卒業後、浜野総合研究所を経て、2003年、都市を対象にプレイスメイキングとプリントメイキングを行うアーキネティクスを設立。都市開発、複合開発等の構想策定、コンサルティング、関連する内容の出版物編集・制作を行う。主な実績に「渋谷QFRONT」、『日本ショッピングセンターハンドブック』共著、『コミュニティシップ』監修などがある。2017年より都市をテーマとした雑誌『MEZZANINE』を刊行。

GREEN Neighborhood
グリーンネイバーフッド
増補改訂版

ポートランドに見る
アルチザンエコノミーという
新しい資本主義のかたち

2022年8月22日　初版 第1刷 発行

著者	吹田良平
	©Ryohei Suita 2022

executive producer　Blue Jay Way

発行者	後藤佑介
発行所	株式会社トゥーヴァージンズ
	〒102-0073　東京都千代田区九段北4-1-3
	電話：(03) 5212-7442
	FAX：(03) 5212-7889
	https://www.twovirgins.jp/

装丁・デザイン	金子英夫 (テンテツキ)
印刷所	株式会社シナノ

ISBN 978-4-910352-42-8
Printed in Japan